# JOHN HOWE

# Fantasy Drawing Workshop

**IMPACT**

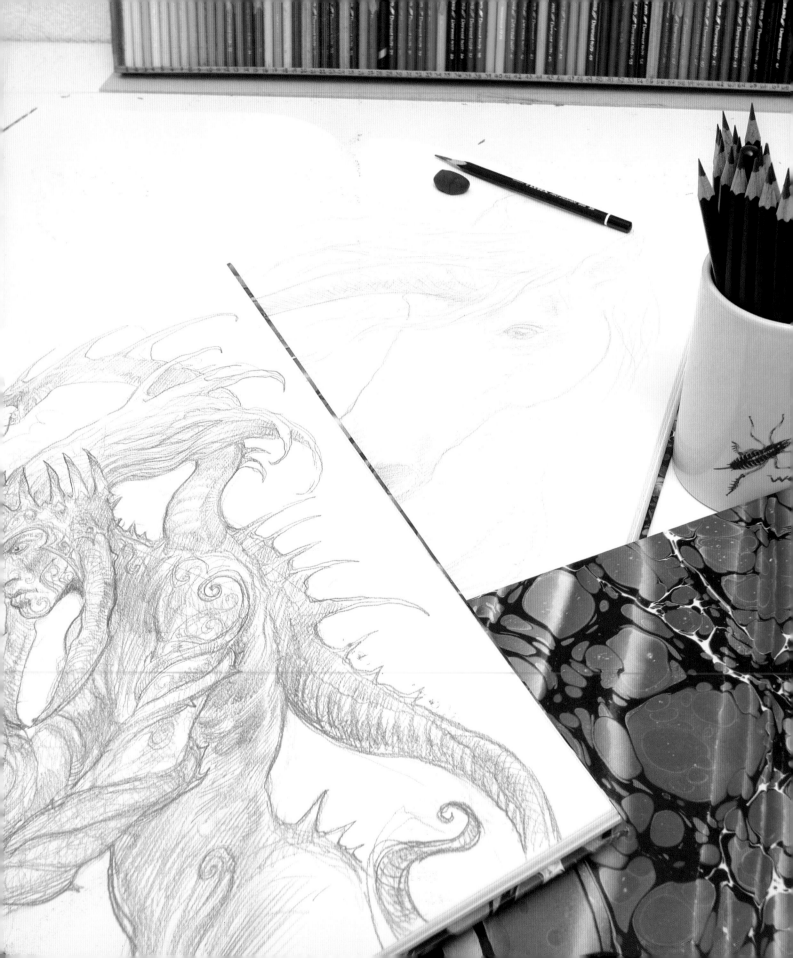

# JOHN HOWE
# Fantasy Drawing Workshop

IMPACT

# A DAVID & CHARLES BOOK

Copyright © David & Charles Limited 2009

David & Charles is an F+W Media Inc. company
4700 East Galbraith Road
Cincinnati, OH 45236

First published in the UK in 2009

Text and illustrations copyright © John Howe 2009

John Howe has asserted his right to be identified as author of this work in accordance with the Copyright, Designs and Patents Act, 1988.

A catalogue record for this book is available from the British Library.

ISBN-13: 987-1-60061-773-7 paperback
ISBN-10: 0-60061-773-5 paperback

Printed in China by SNP Leefung
for David & Charles
Brunel House   Newton Abbot   Devon

**Senior Commissioning Editor:** Freya Dangerfield
**Editorial Manager:** Emily Pitcher
**Editorial Assistant:** James Brooks
**Designers:** Martin Smith and Jon Grimes
**Project Editor:** Cheryl Brown
**Photographer:** Kim Sayer
**Production:** Ali Smith
**Indexer:** Lisa Footitt

**Visit our website at www.davidandcharles.co.uk**

David & Charles books are available from all good bookshops; alternatively you can contact our Orderline on 0870 9908222 or write to us at FREEPOST EX2 110, D&C Direct, Newton Abbot, TQ12 4ZZ (no stamp required UK only); US customers call 800-289-0963 and Canadian customers call 800-840-5220.

# CONTENTS

*Pandora*
*I've always wondered if evil truly*
*emerged when Pandora opened*
*the box, or had always been*
*lurking in the shadows, eager for*
*someone to pin the blame on.*

# FOREWORD
## BY ALAN LEE

Having worked in almost every medium, and almost every circumstance, over nearly 40 years as an illustrator and designer, I am still charmed by the magic of those initial moments in the creative process – simply picking up a pencil, sharpening it, and drawing a faint, exploratory line on a clean sheet of paper. How that trail of graphite can suddenly shift into becoming the branch of a tree, the profile of a queen, a moment in a story, is still quite mysterious, so John's attempts to examine and reveal the process of sketching are going to be as enlightening for me as for any other reader of this book.

If I can add anything at all to John's thoughts on the subject, it would be to stress how important I believe it is to draw from life, from the world around you, as well as from your inner world. The information that you glean through observation – and there is no better way of observing an object than by drawing it – will feed a level of veracity into drawings that come from the imagination. Even if there is no

obvious relation between the two, your increased understanding of the effects of light on different shapes and textures, of perspective and form will enhance your ability to make even the most fantastic subject-matter believable.

It is also invaluable to spend a lot of time drawing from the imagination. I have filled many sketchbooks with idle doodles, started with no particular direction in mind, and for the most part, not resolved in any way that would make sense to an observer. My excuse is the belief that drawing skills and the imagination – like any other faculty - will both be exercised and strengthened by constant use, but I really just enjoy watching, rather than guiding, the process as these strange creations appear on the page. The most interesting things happen though, when I have been out drawing trees in the woods, or a

collection of pebbles, or a close-up of someones face, and then go back to drawing from the imagination. That period of concentrated study of intricate forms is released onto a new page in an outburst of images made even more fantastic through being informed by the almost unimaginable complexity or subtlety of nature.

I also love sketches that have a purpose, that are an incidental by-product of the process of creating a picture, or working out a design - that exist to communicate an idea, and not to be a work of art. Many of these drawings are beautiful because they are un-selfconciously just doing their job. So, sharpen your pencils and get sketching; there are oceans of stories, extra-ordinary inventions, natural and unnatural wonders and new cosmologies lying just below the surface of that blank sheet of paper, waiting to be brought to life!   *Alan Lee, May 10, 2009*

# INTRODUCTION

Drawing allows you to move between two worlds, the physical and the imagined, with fantasy subjects as your stepping stone. I confess to being a serial sketcher. Without sketching, sketching and more sketching, I would not be able to create the work I do. A sketch provides an indispensable dialogue, a give-and-take between an idea and its visualization. Some may be quickly abandoned, others veer off on unexpected detours; some will develop into finished renderings, others are preliminaries to colour paintings.

*These sketches were done at an early music festival in France one summer. While my wife and son (the musicians in the family) were off doing musician things, I would sit at a café and sketch. I had no clear ideas in mind, but being surrounded by ancient instruments my mind turned to unexpected themes I would never have otherwise visited. (I also took hundreds of photos.)*

*Inspired by the beautiful instruments that were just everywhere, a story appeared, a tale of a wandering musician who coaxes melodies out of trees and plants. Little snippets of text followed each sketch. Often a series of sketches will take on a narrative flow of its own. The trumpet-snouted musician above was partly inspired be memories of the paintings of Hieronymous Bosch and a beautiful choir stall sculpture in a local church.*

# ABOUT THIS BOOK

Primarily, this book is a step-by-step explanation with running commentary on ten sketches or drawings for as many fantasy themes. The ten drawing projects are designed as a course that will advance your ability and skills as you work through them. The commentary is written to be as clear and helpful as possible; if you follow each step, you will indeed end up with a drawing and, if we have done our job properly, you will have picked up something more. Something not entirely explained in these pages. For this book is not *really* a method. I dislike methods – I regret that they are a finality. This book wishes to be more of a guide, an entreaty to retain your own personality and individuality as you make your own versions of the drawings. By experiencing the way these sketches progress, the twists and turns of their development, the pentimentos and palimpsets, I hope that you will be strengthened in your desire to be spontaneous, imaginative and original in your own drawing efforts.

*A sketch done very quickly in a museum; I was trying to capture the pose of a statue (cameras were not allowed). Even a quick sketch, imperfectly scribbled in too little time, can be a precious reminder of a fleeting idea.*

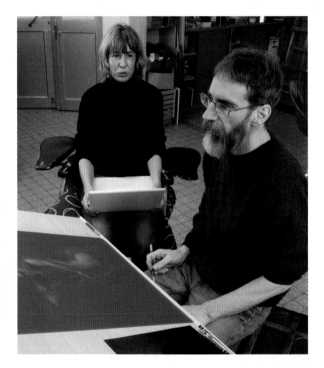

I'd like to think that this is about as close as you can get to watching me draw without coming to my studio and looking over my shoulder. In fact that is pretty much what happened: my editor and her photographer came to visit me to record me drawing (as shown in the picture to the left). The resulting photos record what works, as well as what doesn't: elements sketched in, erased, and sketched in again; ideas abandoned, proportions adjusted, the translation of preliminary sketches to final drawing – none of it has been left out. Indeed, there are drawings in here I would happily do again, but that too is part of the whole process.

This book has been created in the hope of closing the gap between those who draw and paint professionally and those for whom it is an aspiration but perhaps not a reality… or not just yet. In my teens, I recall slavishly copying the drawings and paintings of artists I admired. How I daydreamed I could have them take me through a sketch step by step, to stand by their shoulders while they worked. I hope that by looking over my shoulder, you gain the confidence from the experience to develop your own drawings.

But will this book teach you to draw ten fantasy characters? Possibly, even probably, but I hope it will do much more than that. I hope simply that it will help you to unlock the freedom of hand and eye that can lead you further; because with that freedom, there will not just be ten, or even ten times ten, but infinite themes and ideas that appear at the tip of your pencil.

*Reference material can be indispensable in many cases, especially where fantasy art (which relies on believability and fantasy in equal measure) is concerned. Here is a part of the eclectic collection of references that have accompanied the drawings featured in this book.*

# SKETCHING OR DRAWING?

*'Art, like morality, consists of drawing the line somewhere.'*
G. K. Chesterton (1874–1936)

Drawing and sketching are often used indiscriminately: a drawing can be sketched, a sketch drawn.
Can we understand more from exploring the origins of the words?

**Sketch** *[Ske ch]*
*vb* from Ancient Greek *schedios* meaning 'made suddenly, off-hand'; also *schediazo*, 'to do a thing off-hand'.

**Draw** *[Dr aww]*
*vb* from Old English *dragan* meaning to drag, used to signify drawing in the sense of a line left by a pen or another instrument.

What really differentiates drawing and sketching, then, is not so much technique as **intent**. A drawing is a finished piece of artwork: sketchy as it may be, it is nevertheless the beginning, development and conclusion of a particular idea or rendering. A sketch, however, while it can also possess intrinsic value and be quite detailed, is just a step towards a final version, the preparation of an idea or the record of an observation for a work to come.

Those two terms, sketch and draw, overlap like cross-hatching and are often interchangeable. At the end of each chapter I hope that you will have produced a drawing that you are happy with for its own sake; but for me, these are sketches that have provided the inspiration to take the ideas on further and I share with you how I might go on to develop these in the What's Next feature at the end of each chapter.

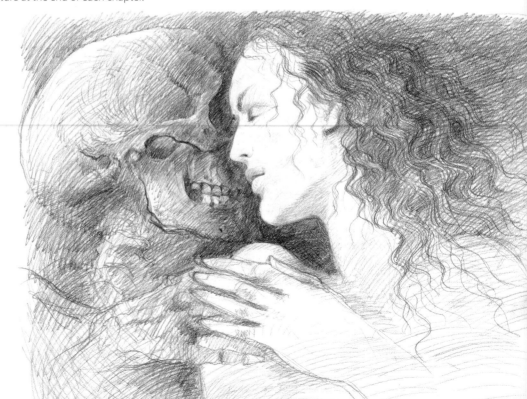

*La Belle Dame Sans Merci*
*Sketch for an unpublished*
*poem by fantasy author Jan*
*Siegel. The Belle Dame is*
*immortal, her lover is not.*

# INTRODUCTION

Drawing is a great way to begin to explore fantasy art and illustration. While painting can be a skill that takes years to perfect, paper and pencil are far more accessible, and you can take your sketchpad with you wherever you go.

Learning to sketch and draw means paying attention to the things that surround us, understanding their structure, finding interest in their line and volume. These skills can then be applied to creating those things which exist only in our minds, the worlds of fantasy that parallel our own. It is my hope that by observing how I have developed the artworks featured in this book, you will be inspired to work up your own fantasy drawings.

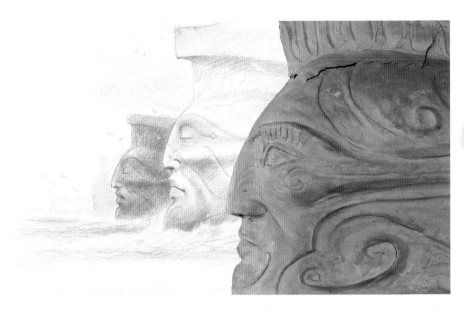

*First a drawing, then a sculpture, then another drawing (the clay model was sculpted by my wife).*

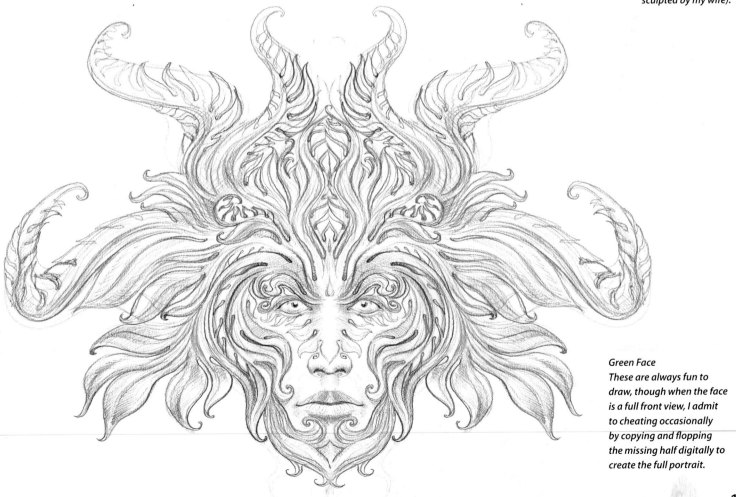

*Green Face*
*These are always fun to draw, though when the face is a full front view, I admit to cheating occasionally by copying and flopping the missing half digitally to create the full portrait.*

11

# Drawing Kit

The drawing materials that you will need to produce the art in this book are very limited and easy to acquire. A few pencils, paper, putty eraser, ruler, craft knife and a board to rest on, and you are ready to begin.

## Graphite pencils

Pencils come in two basic grades: from the very hardest 9H to the soft 8B, ('B' stands for 'black' because of the darker marks soft pencils make). B pencils are easier to work with when drawing; the lines they leave can be easily blended, smudged and erased, as less pressure is required to make them. Graphite pencils grade 3B and 4B are used for the drawings in this book. (The higher the number on a B pencil the softer it will be).

There are so many graphite pencils available on the market that it can be hard to choose: the best course is to try out a few brands until you find one that suits you.

*Pencil extenders are a good investment as they will ensure that you are able to use the pencil right down to its very end.*

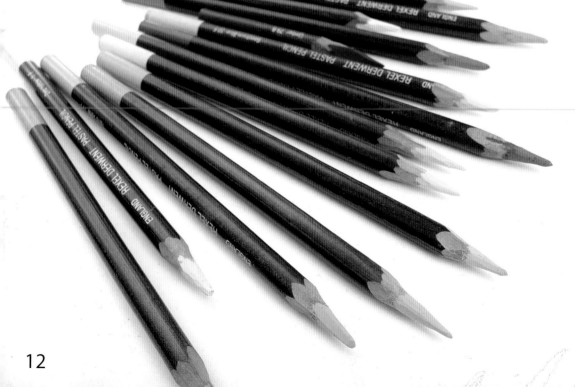

## Pastel pencils

The pastel pencil is a wide, hard pastel lead contained within a shaft. Pastel pencils have all the advantages of pastel sticks without the drawbacks: they won't break easily and the colour will not come off in your hand. They can painlessly introduce colour to your drawings and possess a rough texture that creates an attractive finish. Beginners and improvers will find pastel pencils easier to work with than traditional coloured pencils: the colour, which can be applied vividly and thickly for fast results, is reasonably easy to remove with a putty eraser.

I have used pastel pencils for two of the illustrations in this book – Lancelot and the Mermaid – and you will find details of the colours required at the beginning of these chapters.

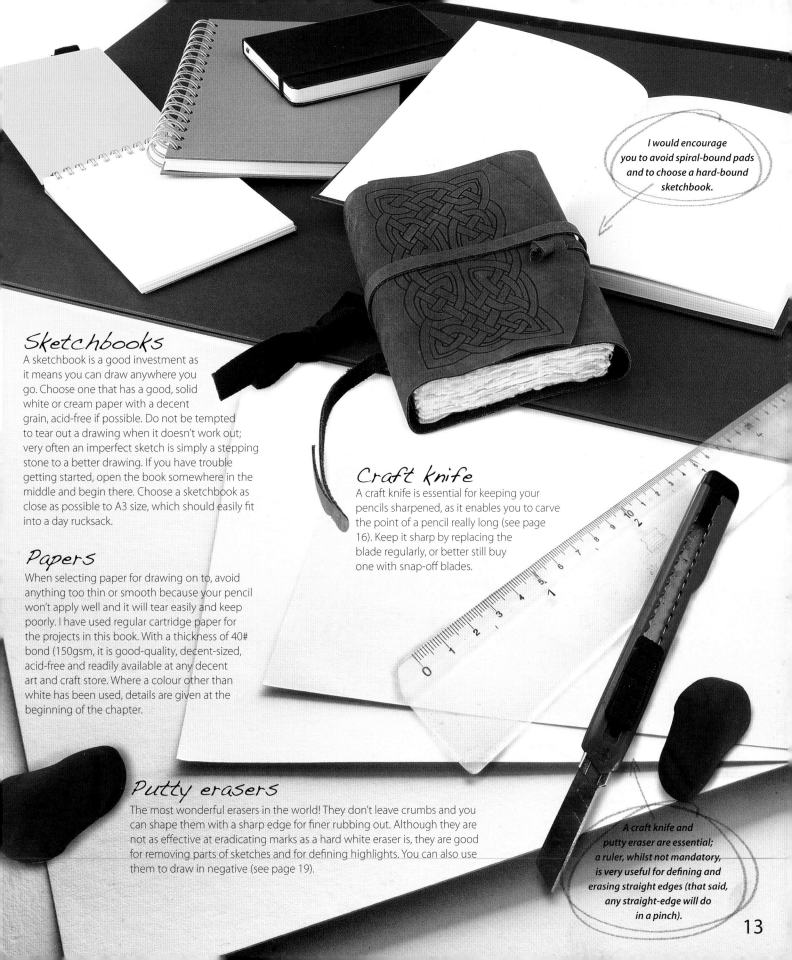

*I would encourage you to avoid spiral-bound pads and to choose a hard-bound sketchbook.*

## Sketchbooks

A sketchbook is a good investment as it means you can draw anywhere you go. Choose one that has a good, solid white or cream paper with a decent grain, acid-free if possible. Do not be tempted to tear out a drawing when it doesn't work out; very often an imperfect sketch is simply a stepping stone to a better drawing. If you have trouble getting started, open the book somewhere in the middle and begin there. Choose a sketchbook as close as possible to A3 size, which should easily fit into a day rucksack.

## Papers

When selecting paper for drawing on to, avoid anything too thin or smooth because your pencil won't apply well and it will tear easily and keep poorly. I have used regular cartridge paper for the projects in this book. With a thickness of 40# bond (150gsm, it is good-quality, decent-sized, acid-free and readily available at any decent art and craft store. Where a colour other than white has been used, details are given at the beginning of the chapter.

## Craft knife

A craft knife is essential for keeping your pencils sharpened, as it enables you to carve the point of a pencil really long (see page 16). Keep it sharp by replacing the blade regularly, or better still buy one with snap-off blades.

## Putty erasers

The most wonderful erasers in the world! They don't leave crumbs and you can shape them with a sharp edge for finer rubbing out. Although they are not as effective at eradicating marks as a hard white eraser is, they are good for removing parts of sketches and for defining highlights. You can also use them to draw in negative (see page 19).

*A craft knife and putty eraser are essential; a ruler, whilst not mandatory, is very useful for defining and erasing straight edges (that said, any straight-edge will do in a pinch).*

# Locations for Drawing

As long as you have paper and pencils, you can draw anywhere. However, if you plan to draw regularly, it makes sense to set up a dedicated space in your home or studio so that you can spend the time drawing and not getting ready to draw. Do not underestimate the importance of getting out and about; drawing on location can bring fresh ideas to your fantasy work.

## A dedicated work space

I have a large studio dedicated to sketching, drawing and painting, since I spend a good deal of time there. Books line the walls and open drawer units are crammed to overflowing with reference material. There are work surfaces for drawing and painting, as well as a high-tech corner for the computer, scanner and printer, hard drives and archiving.

There is no doubt that you will work more effectively if you find yourself a space to draw. It doesn't have to be big, just a corner of a room will do, but it should be a space where you can leave your things without having to clear them away every night. Put up a shelf for any reference books you collect and a pin-board for inspirational pictures. Make sure the space is well lit and the chair you choose is comfortable and adapted to your posture.

*I have regular angle-poise lights – decent lighting is essential in any studio. Natural daylight is of course always better than artificial light if you can arrange your workspace accordingly.*

*A system of open drawers makes a vast amount of documentation quite manageable. Ring binders can be torture – it always seems so easy to take documents out, but putting them back is rather more laborious.*

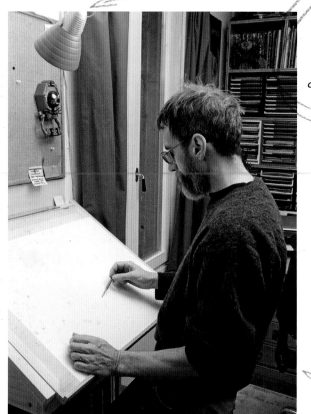

## My sketching pulpit

There is a spot in my studio dedicated to sketching, which I have dubbed my sketching pulpit. Built rather as an afterthought between shelving and a window, it has an angled surface just big enough to take the large sheets of drawing paper that are sold in most art shops. I can pile up a dozen sketchbooks inside it and there is a handy shelf on the left for pencils and other drawing materials. Nowhere near as cumbersome as a full-fledged draftsman's table, it takes up surprisingly little room.

The pulpit is high enough to comfortably use standing up without resting elbows on it. This is a very effective way to work and encourages using the whole arm, sketching freely from the shoulder, with the hand kept free and unconstrained. The drawing itself is also easier to see in its entirety. Distancing yourself from the reflexes of writing will allow you to approach your drawing with fresh perspective (for more on this, see Working with the Pencil, page 17). You can create similar conditions yourself by propping a board up on a table, or by fixing your board to a sketching easel.

*Drawing standing up, having the arm physically free from the shoulder to pencil tip, has a corresponding metaphysical freedom.*

## Finding inspiration

Unless you are blessed with a photographic memory, reference material is paramount. Collect as much visual information as you can that may help you to realize your fantasy subjects: books on foreign countries, landscapes, history, natural history and art; pictures clipped out of magazines; your own photographs of landscapes, objects and people. Fantasy is a heightened form of reality, and a serious dose of realism can make it work all the better.

The more you see and the more you are interested in, the freer you will be to create. Your aim is to take the information you have gathered and to use it to inspire you in your fantasy art.

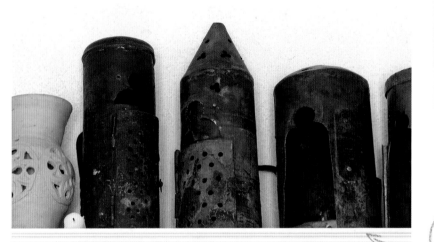

*My studio is full of props and objects – helmets are cumbersome things, but can live happily tucked away atop a bookshelf.*

*A shelf full of jugs, drinking vessels and lanterns of various sorts: even the small details are important to get right.*

## On location

Getting out of the studio can be a good thing, and acquiring the confidence to quickly sketch 'in situ' can be a real asset. Cameras are not always welcome in every situation, especially in museums.

When travelling or drawing out of doors it is best to travel light: just a ledger size (A3) sketchpad and a pencil case with knife, eraser and a few pencils (my current sketchbook lives in a backpack just big enough to slide it in).

Don't underestimate the importance of getting out and about. It's easy enough to sketch in pretty much any condition except rain or strong winds. The time spent drawing an object or a vista may not give you as attractive a result as a camera can, but at the very least you will have spent time understanding what it is you are drawing (a good combination of the two tools is best: sketchbook to draw and create, and camera to back you up). Even if your sketch isn't that exciting or satisfying, you will have gained from the observational exercise. For an artist, sketching on location is pretty much the equivalent to a musician playing scales on a piano.

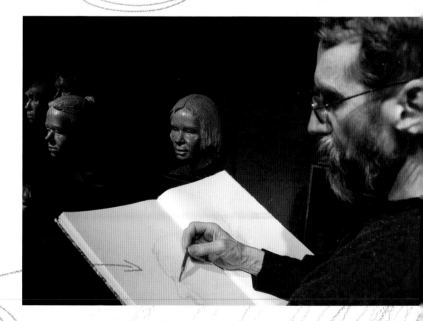

*You will have to be adaptable – there is no sketching pulpit on location. Most often you will have to stand up and hold the book.*

# Working with the Pencil

The pencil is your most important tool – it should be a harmonious extension of your arm. The pencil used primarily as a drawing instrument, as opposed to a drafting or writing instrument, demands very different treatment.

## Sharpening a pencil

I far prefer to rely on a craft knife to sharpen my pencils to long points and profess a dislike of pencil sharpeners. The perfect mechanical point they produce is intended for writing or drawing with a ruler, and is hardly apt for sketching. Hand-sharpening a long point will allow you to hold the pencil nearly flat to the paper, and provide the best control when drawing. Held at the very back end, the weight of the pencil itself is enough to leave a light line.

To sharpen your pencils, here are three simple steps. These instructions are for a right-handed person, and left-handers should of course reverse them.

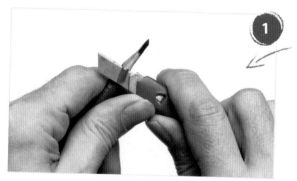

**1** Hold the craft knife in your right hand and the pencil in your left, grasping each firmly between thumb and forefinger, using your other fingers to hold them in place. Rest the craft knife above the left thumb.

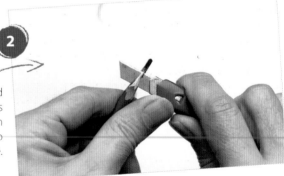

**2** Draw the pencil back against the blade, keeping the craft knife steady and still throughout. The pencil is sharpened by pulling the pencil backwards against the blade of the knife. **Do not** push the blade forwards through the wood. It's important to retain contact between the thumbs, and to keep a firm but controlled grasp on the knife.

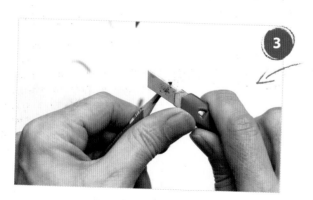

**3** As the long graphite point develops, shave the top of the nib as you turn it to achieve a fine point. A 'personalized' point will be better adapted to your drawing style.

### Artist tip
Sometimes you get a pencil where the lead will break constantly – it has been broken or weakened within the pencil itself. Usually, however, pencils are very sturdy, and you should have no trouble getting a point that is very long even with a 4B lead.

## Holding the pencil

Give an adult a pencil and ask him to hold it the way he would to draw, and nine times out of ten he will hold it in exactly the same manner as he would to write with. While the tools are identical, the two activities couldn't be more different.

Writing is an intellectual, thinking activity, managed by the left-hand side of the brain, with the mind concentrating fully on the letter at hand, to staying on the lines, to being neat and legible. Drawing, however, relies more heavily on the right-hand side of the brain – the instinctive, intuitive, emotional side. Aiming to work freely, to see the bigger picture, to explore proportions and the overall composition is the purpose of this exercise. By picking up the pencil as if we are about to write with it, we are immediately sending the wrong message to the wrong parts of our brains.

To rediscover the ease with which children draw, it may well be necessary to unlearn our writing reflexes and replace them with those better adapted to drawing. For those who have acquired a certain number of bad drawing habits, this may not be easy, but it can be done.

### For sketching and establishing lines

I would be seriously tempted to forbid holding a pencil the way you do to write. At any rate, never hold it close to the writing end unless you are working on tiny details. Holding a pencil about halfway down, and like a conductor's baton, raises the hand and wrist off the page and allows for large, open movements when drawing. It allows you to apply very light pressure with looser control over the pencil and greater suppleness of line.

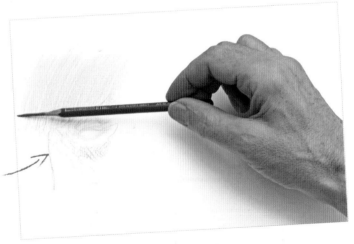

### For shading

Here I'm holding the pencil right at the end of the shaft, and using the weight of the pencil alone to create the marks on the paper. In a sense, this position allows you to have even more freedom than the hold above. Cross-hatching holding the pencil like this, you can build up an even, grey background. (Don't worry about running over the outlines; you can always tidy up with a putty eraser.)

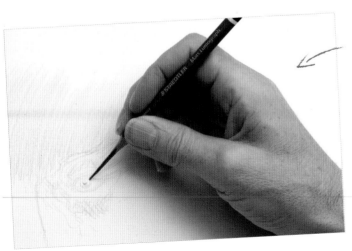

### Working on details

This is the exception to the rule. When you wish to do very fine detail over a very small area, hold the pencil as you would to write, and take advantage of the vertical angle and concentrated field of vision to work on those tiny bits.

## Artist tip

When you hold a pencil close to the point as if you were about to write, with the heel of your hand posed on the page, the amount of paper you can draw on is very small and constrained. Holding your pencil in different ways will free up your movements and make the entire drawing surface available in one gesture.

17

# Drawing Techniques

Ask someone to write a few words in large letters in a given space. Habitually, letters start out amply written, only to end up with the last few crammed in on the right. Drawing the same letters will be more likely to produce a harmonious arrangement because the eye is seeing the whole space and not just the letter being made.

## Five easy steps

If I had five top tips to release your drawing hand from your writing one, they would go like this:

**Step 1:** Stay sharp. Sharpen your drawing pencils into long points with a craft knife (see page 16) so that you can hold your pencil as flat to the paper as possible when necessary.

**Step 2:** Get a grip, lightly. Hold your pencil as far away from the tip as you can, like a magic wand, a stick, a conductor's baton, any way but the way you'd instinctively hold it to write. Just the weight of the pencil will leave a light line that can easily be erased if need be, allowing you to sketch and block in ideas freely.

**Step 3:** Back off. Get your hand and wrist off the page (see step 2, page 17). Allow your arm to be free from the shoulder or, at the very least, from the elbow. You have an area half a yard square to work with (see step 4), so don't be afraid to use it. Lean in close and pose your hand when you wish to work details, but don't forget to keep stepping back to see the bigger picture.

**Step 4:** See the bigger picture. Don't make the mistake of confusing stationery with art material. An A3 format is really quite small; twice that size is better. Sketching has a lot in common with fencing: you want to see your entire opponent, not just his sword point. Learn to work with the whole drawing surface and don't be afraid to adjust, develop and even change your ideas as you go. Keep your eye on the whole picture, not just on the line you're drawing. Choose the the distance you wish to be from the drawing surface; do not let old or bad habits choose it for you.

**Step 5:** Switch off. Let your pencil wander; let your instinct and intuition take over. Have you ever wondered what happens in an illustrator's head when he draws? Well, in mine, not a lot, at least not on the thinking side.

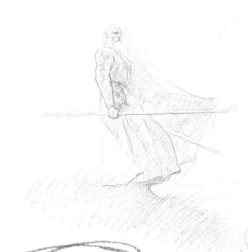

*A quick thumbnail sketch helps to make decisions about the composition of a drawing and to work within the available space. Tucked away in the corner it remains useful throughout – or at least until it gets covered over and eventually erased by the drawing itself.*

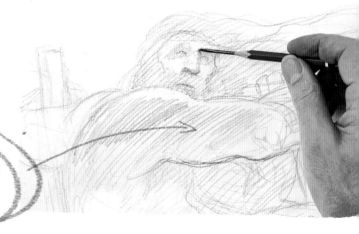

*Keep your drawing loose. In Thor and the Giant I was undecided how to position the giant's left arm. In the initial stages he had two, one around the stern, the other holding the rudder. Rather than compromising a whole picture for an ill-placed detail, it's far better to either erase (if you drew it once, you can draw it again) or to turn the page and start anew.*

## Pencil techniques

While I do believe that pencil lines should occur as natural gestures, there are a few shortcuts that can be tailored to the needs of everyone. This page shows a selection of looser techniques.

### Hatching

### Cross-hatching

Use hatching to shade as on Merlin's shoulder.

Use strong hatching to build volume, as on the dwarf's beard.

Use rounded directional hatching for shaping as on the dwarf's arm.

Cross-hatching helps to build volume and texture as on the dragon's belly.

### Short pencil marks

### Bold directional shading

### Smudging

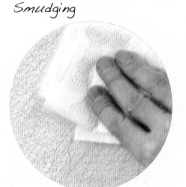

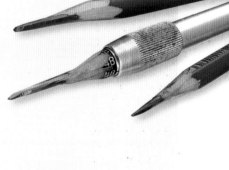

Ideal for creating chain mail on the orc.

For quickly blocking in an area as with Arwen's bustline.

An effective way to create an atmospheric background for the balrog.

### Scribbling and squiggling

### Drawing with a putty eraser

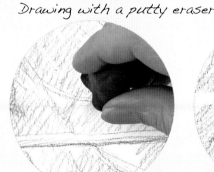

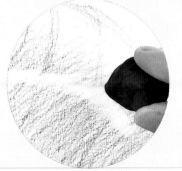

Scribbled lines give the impression of hair for the dwarf.

Using a putty eraser to draw the rain driving across the figure of Merlin.

Using a putty eraser to create highlights as on the orc's armour.

# Drawing a Face

Faces, like hands, are hardest, because we know them so well. Mastering even simple proportions can be an incredibly important step to creating convincing fantasy characters.

**1** *Positioning the guidelines*
First, sketch in the guidelines on which the structure of the face will be built. Outline the head, and place a vertical line down the middle of the face, and then three horizontal positional lines for the eyes, nose and mouth.

*Drawing the nose*
Draw in the bridge of the nose, ending by shading in a triangular tip pointing down from the nose line.

**2**

**3**

*Placing the eyebrows*
Work on placing the eyebrows starting at the intersection of the vertical line and the eye line. Roughly position the ears.

**4**

## Blocking in features
Then block in the lips, chin and cheekbones.

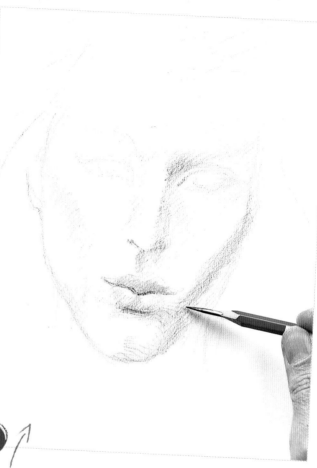

**5**

## Structuring the cheeks
Now begin to draw in the lines of the cheeks to begin to give the face structure.

**6**

## Sketching in the eyes
Finally work up the eyes. The basic character outline is now complete.

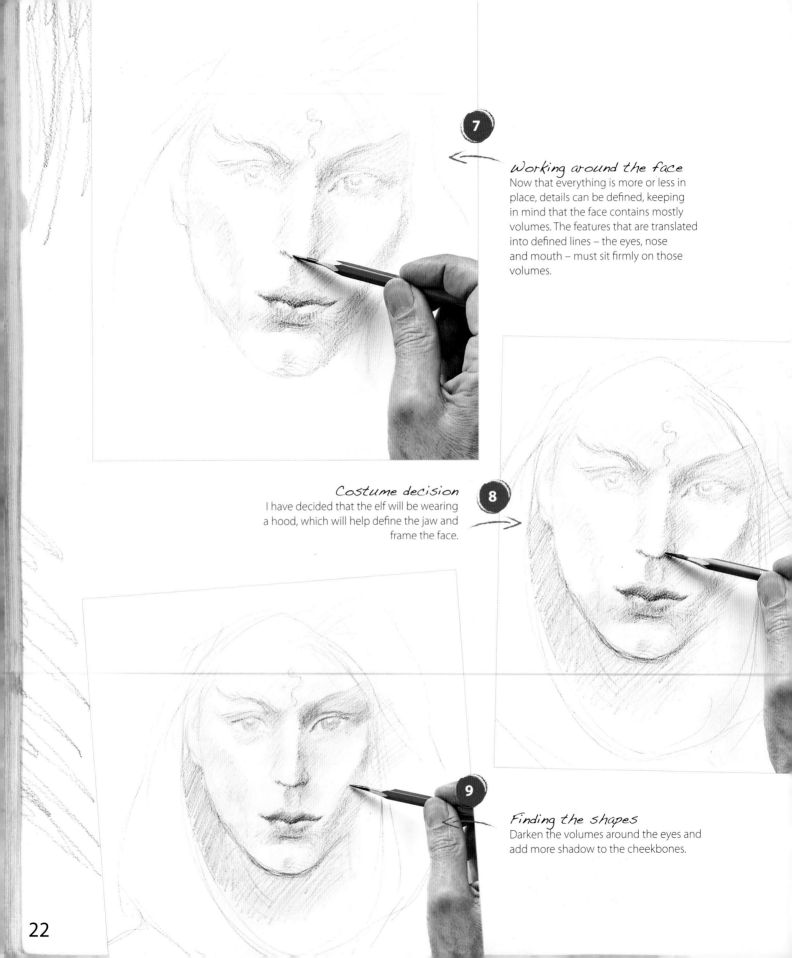

**7**

*Working around the face*
Now that everything is more or less in place, details can be defined, keeping in mind that the face contains mostly volumes. The features that are translated into defined lines – the eyes, nose and mouth – must sit firmly on those volumes.

*Costume decision*
I have decided that the elf will be wearing a hood, which will help define the jaw and frame the face.

**8**

**9**

*Finding the shapes*
Darken the volumes around the eyes and add more shadow to the cheekbones.

22

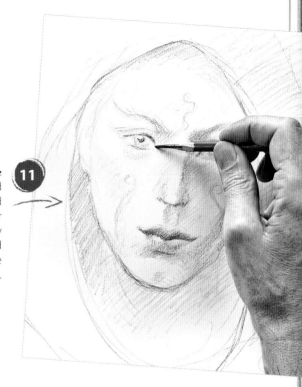

**10**

### Building volumes
Continue to reinforce lightly sketched elements, working across the face wherever needed.

**11**

### Haste makes waste
Now that things are in place and the volumes have been sorted out, it's possible to work into finer details. Going relatively slowly and lightly means you can avoid mistakes and erasing, which can be hard to repair.

### Fine and final detail
Adding a few stray strands of hair is a way to indicate character and a hint of backstory. Highlights can be done with a putty eraser shaped to a sharp edge.

**12**

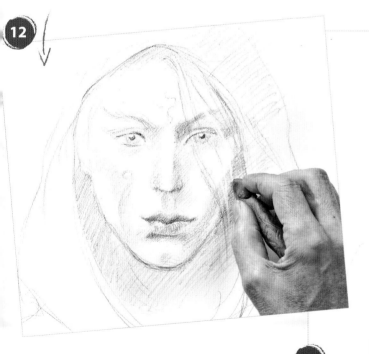

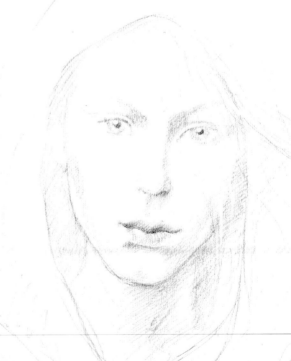

**13**

### Done
The final sketch is still quite rough but it's adequate to move on to either a more finished version or a colour piece.

# Pages from My Sketchbook

Here are a few pages from my sketchbooks. This is a varied selection of work and many of these were preliminary ideas that were subsequently developed into colour paintings. A stack of filled-up sketchbooks is a kind of treasure-trove of forgotten ideas that can later be rediscovered.

SMAUG THE GOLDEN

*A sketch of J.R.R. Tolkien's iconic dragon Smaug. Being a king among dragons, and rather vain about his appearance, he has a crown-like arrangement of spikes and spines studded with jewels.*

*Rather than drawing something from my imagination, drawing what's in front of my eyes can make a refreshing change. While I was doing this sketch, my wife was producing a lovely water-colour and our son was practising the lute – a studious trio on vacation in Greece.*

*This was also done on vacation, during an idle hour. One of the benefits of taking your sketchbook out of doors is that if you run out of ideas you can always fall back on the view.*

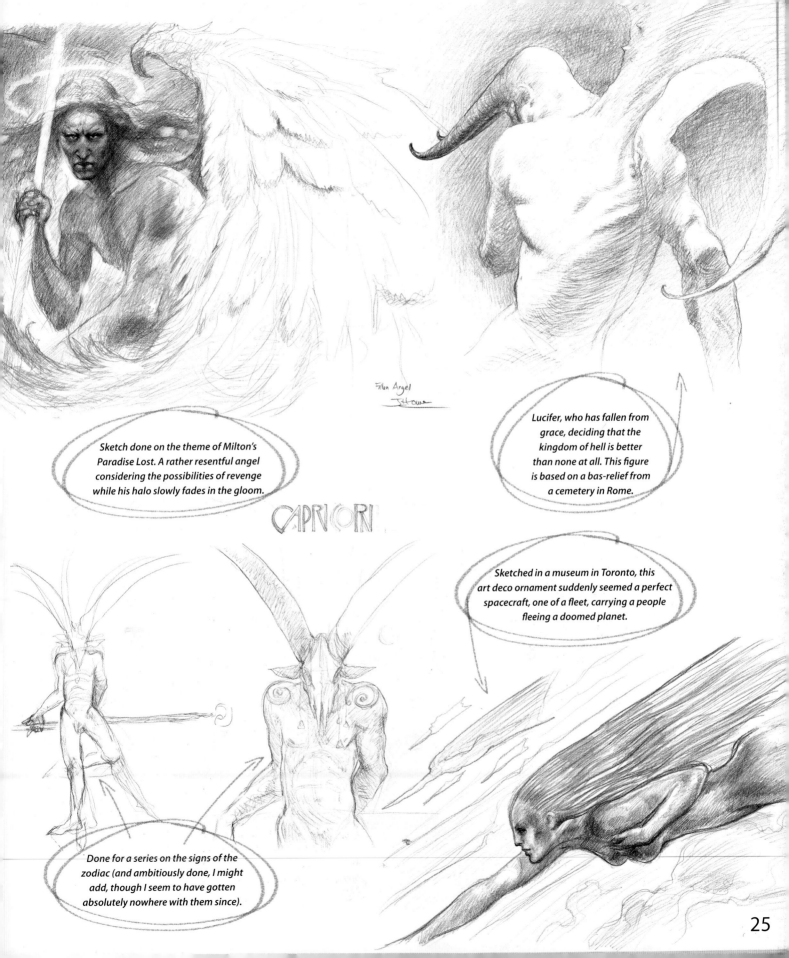

Falen Angel

Sketch done on the theme of Milton's Paradise Lost. A rather resentful angel considering the possibilities of revenge while his halo slowly fades in the gloom.

Lucifer, who has fallen from grace, deciding that the kingdom of hell is better than none at all. This figure is based on a bas-relief from a cemetery in Rome.

CAPRICORN

Sketched in a museum in Toronto, this art deco ornament suddenly seemed a perfect spacecraft, one of a fleet, carrying a people fleeing a doomed planet.

Done for a series on the signs of the zodiac (and ambitiously done, I might add, though I seem to have gotten absolutely nowhere with them since).

# MERLIN

There are as many Merlins as there are texts that mention him. Merlin is the hero, or the figure in the shadows – kingmaker, prophet, bard, druid, keeper of secrets – of countless stories in Welsh literature and Arthurian legend. Drawing Merlin means choosing time and landscape, costume and context, imagining a story that creates the implicit frame of the portrait.

## Project techniques

- Building a basic character composition
- Using a thumbnail to establish composition
- Simple shading for volume

## Ideas and inspiration

My drawing of Merlin is the kind of pencil study I would do before starting work on a painting, to establish the character's basic composition in terms of pose and initial detailing. I have settled on a classic pose – Merlin standing on a cliff top facing out to sea with the wind and rain driving behind him.

## Thumbnail sketch

Thumbnails are quickly done and can rapidly resolve many issues, helping you to decide how you want to place the different elements. Tucked away at the bottom right of my drawing, the thumbnail sketch will come in handy as the drawing takes shape although it will likely get drawn over in the process.

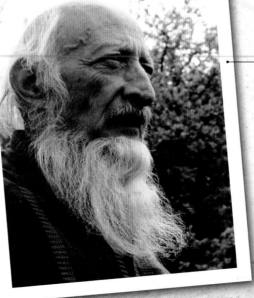

## Project references

Since there's no one Merlin I have one of my own – a retired civil engineer from the Swiss Alps, who graciously allowed me to take a series of portraits. I tracked him down through a photo glimpsed in a magazine and he's been my Merlin ever since.

Working with a 4B pencil, first lightly sketch in Merlin's torso and head. 'Lightly' is the key word here; normally just the weight of your pencil is enough to leave guiding lines sufficiently clear for you to build upon without getting in the way later.

Further define the torso and sketch in Merlin's arm. Now lightly sketch in his legs as a reference point – this helps to anchor standing figures early in the process. Then sketch his robe billowing out in the wind. Place the sloping ground on which he is standing below the robe, then sketch his staff.

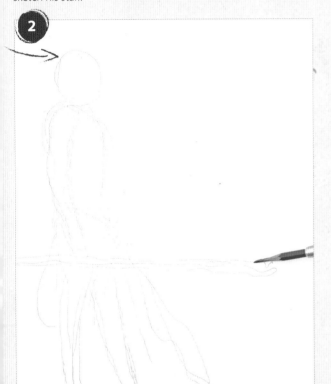

Add the edge of Merlin's cloak billowing out before him.

## Artist tip

Cloaks are always a wonderful element to play with which do so much besides establish context; they can gracefully depict the wind, its direction and strength and so create atmosphere.

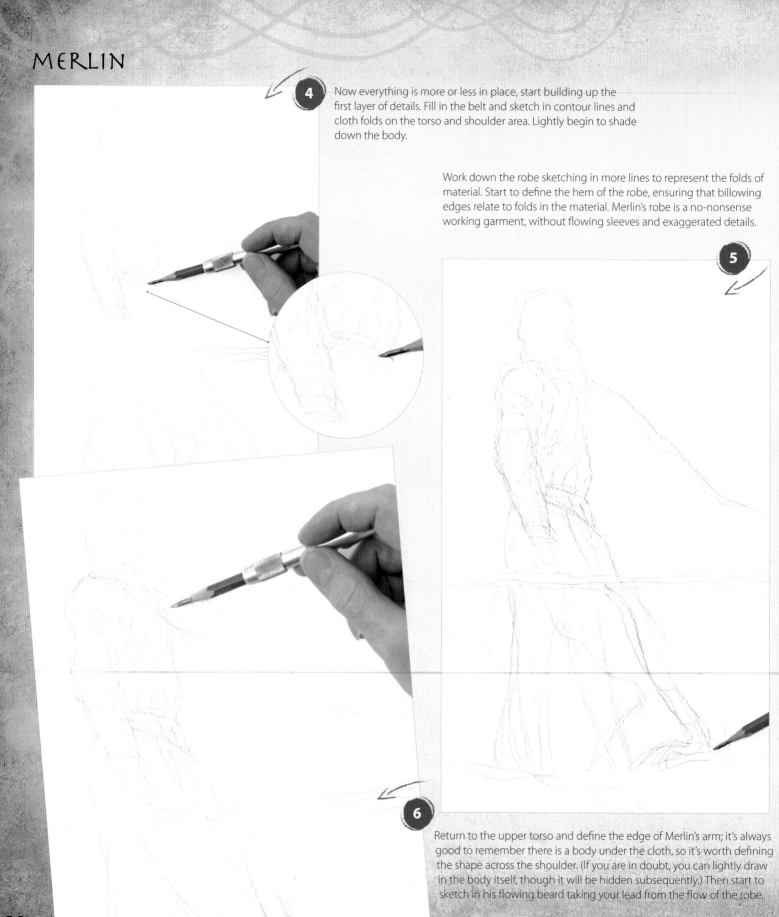

**4** Now everything is more or less in place, start building up the first layer of details. Fill in the belt and sketch in contour lines and cloth folds on the torso and shoulder area. Lightly begin to shade down the body.

Work down the robe sketching in more lines to represent the folds of material. Start to define the hem of the robe, ensuring that billowing edges relate to folds in the material. Merlin's robe is a no-nonsense working garment, without flowing sleeves and exaggerated details.

**5**

**6** Return to the upper torso and define the edge of Merlin's arm; it's always good to remember there is a body under the cloth, so it's worth defining the shape across the shoulder. (If you are in doubt, you can lightly draw in the body itself, though it will be hidden subsequently.) Then start to sketch in his flowing beard taking your lead from the flow of the robe.

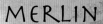

Start to think about Merlin's face. Sketch in his eyebrows, ear and hairline. Then add light shading for his eye sockets, nose and mouth. Shade down the torso with bold directional lines, and further define the arm and shoulder.

**7**

**8**

Re-position the staff and erase the old one. Add some further shaping to the front of the torso and then shade down the arm and over the lower robe area.

Now draw a firmer edge to the robe and move back to work on the hand that needs to grasp the staff. In this case we'll keep it relatively simple – just the back of the hand with some indication of the fingers grasping the staff.

**9**

## Artist tip

*Hands can be real stumbling blocks. Try to observe and sketch hand positions whenever you can; it's the best way to gain familiarity with their structure and movements. A mirror will let you draw both hands, and if necessary, anyone willing to pose for a couple of minutes can be very ... handy.*

# MERLIN

Now start to establish the character in the face. Gently rub out the earlier positional sketch lines and re-establish the basic head shape. Position the eyebrows and the eye sockets, and the outline of the nose. Place the hairline and the ear adding some shading around the neck and collar. Then add more depth to the hair flowing over Merlin's shoulder and to his beard.

Add further depth to the belt and firmly establish the front of the torso. Lightly smudge some of the shading here to build the volume. Then sketch in the sword, which Merlin is holding in his other (unseen) hand. Even a discrete element like this can add a background story and imply a narrative.

Now start building up more volume on the torso. Hatch across the top of the shoulder and down the front of the torso, again smudging some of the line work to create depth. Suggest where the belt buckle will go, and extend the belt end out in front to show it too blowing in the wind.

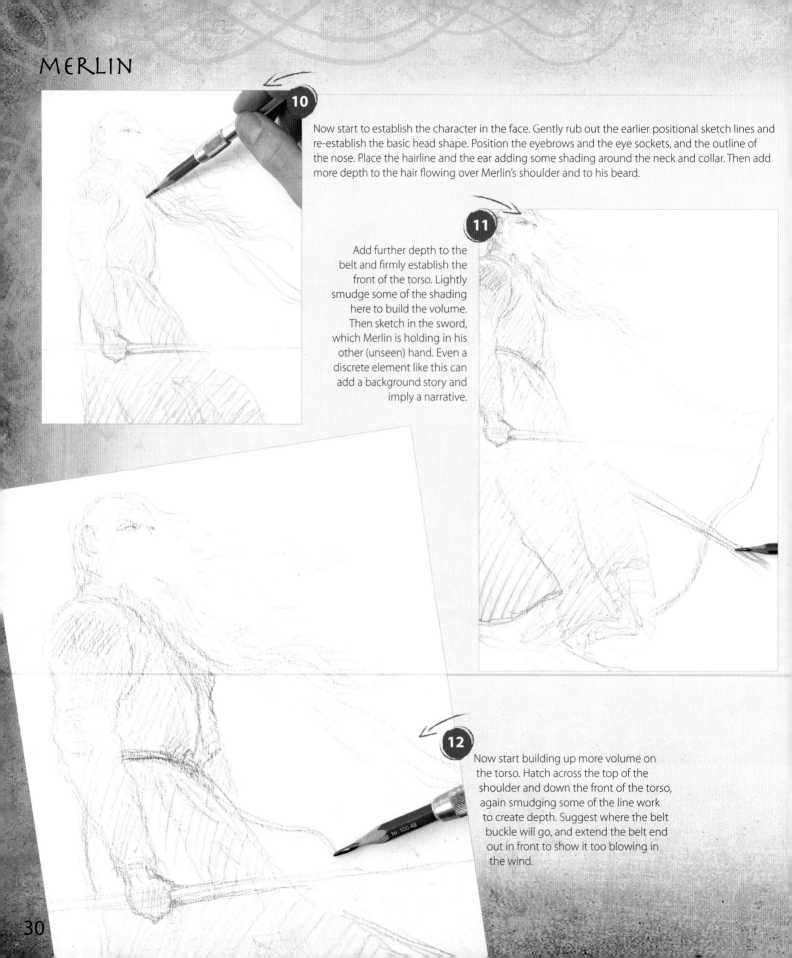

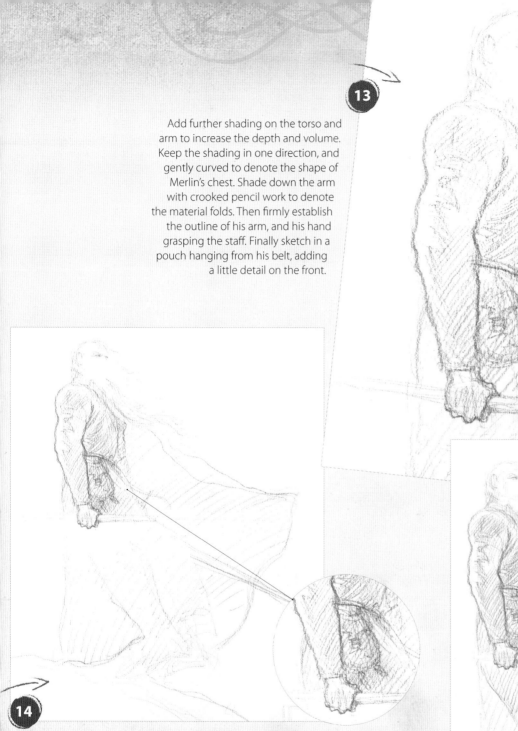

**13** Add further shading on the torso and arm to increase the depth and volume. Keep the shading in one direction, and gently curved to denote the shape of Merlin's chest. Shade down the arm with crooked pencil work to denote the material folds. Then firmly establish the outline of his arm, and his hand grasping the staff. Finally sketch in a pouch hanging from his belt, adding a little detail on the front.

**14** Add some further detailing at the top of the pouch where it attaches to his belt. Then shade down the inside of the cloak, again keeping the hatching following the movement of the cloak.

**15** Now do some further work on the lower half of Merlin's figure. Sketch in some stronger folds in the robe, using an eraser to lift out any highlights. Then carefully deepen the shading in each section between the folds. Work down to the base of the cloak and deepen the hemline, shading below it to indicate the shadow as shown. Lightly sketch in his feet; this need only be a loose indication so there is no need for detail.

# MERLIN

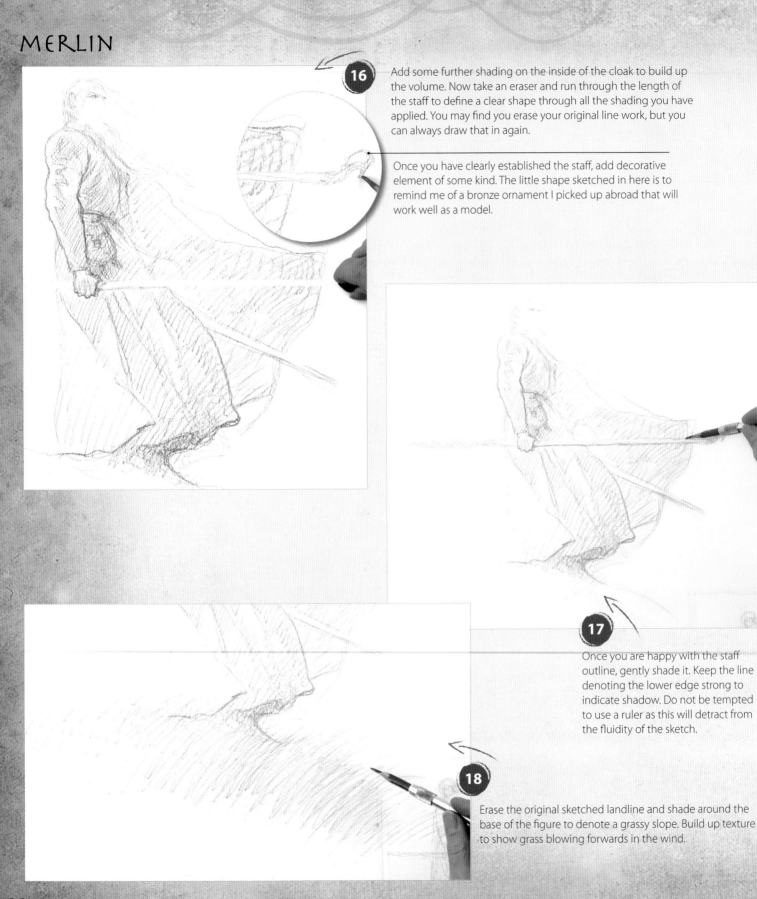

**16** Add some further shading on the inside of the cloak to build up the volume. Now take an eraser and run through the length of the staff to define a clear shape through all the shading you have applied. You may find you erase your original line work, but you can always draw that in again.

Once you have clearly established the staff, add decorative element of some kind. The little shape sketched in here is to remind me of a bronze ornament I picked up abroad that will work well as a model.

**17** Once you are happy with the staff outline, gently shade it. Keep the line denoting the lower edge strong to indicate shadow. Do not be tempted to use a ruler as this will detract from the fluidity of the sketch.

**18** Erase the original sketched landline and shade around the base of the figure to denote a grassy slope. Build up texture to show grass blowing forwards in the wind.

Now move back to the face. Change to a finer 3B pencil so you can capture the detail and first establish the nose working in a straight line down from between the eyes, and then add the mouth. Then add a line to denote the creases at either side of the mouth; shade upwards into the cheek area and up the side of the nose, leaving a highlight for the top of the nose. Add some further shading below the chin for the beard.

**19**

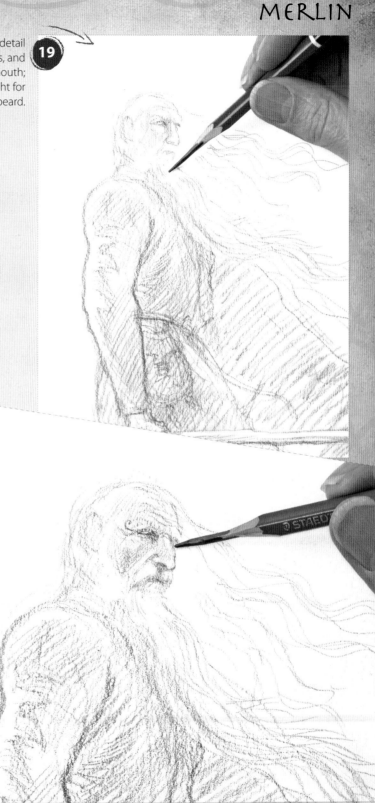

Add some further light shading around the mouth, and a firm line for the lip. Further define the contours of the nose and face, and deepen the shading on the eye sockets. Add the tattoo near the corner of Merlin's right eye.

**20**

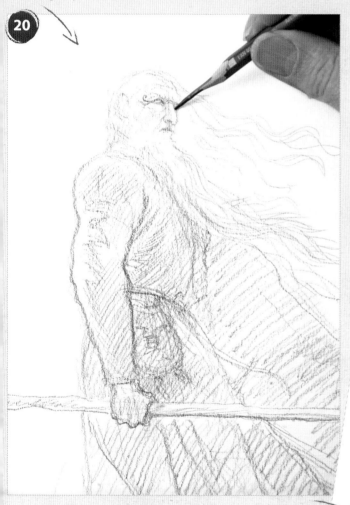

**21**

Add further shading to the cheek area, adding depth to the cheekbones. Then move back to the eye sockets and add further definition. Add fine lines over the forehead to define Merlin's windswept hair and the wrinkles beneath.

# MERLIN

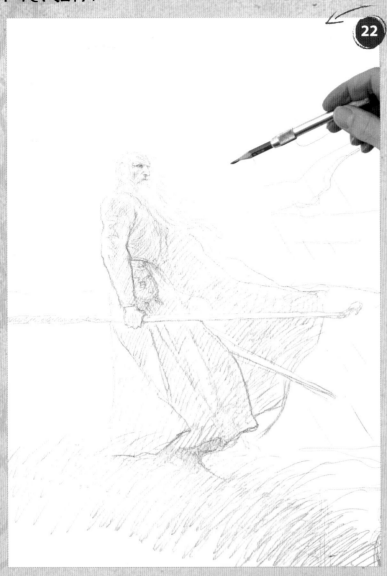

Add the outline of a cliff in the background and sketch in some clouds; this is all to enhance the atmosphere of the piece and requires very little definition. With bold strokes, indicate the driving rain.

23

To indicate the rain driving across Merlin's body, take the eraser and drag strokes through the shading.

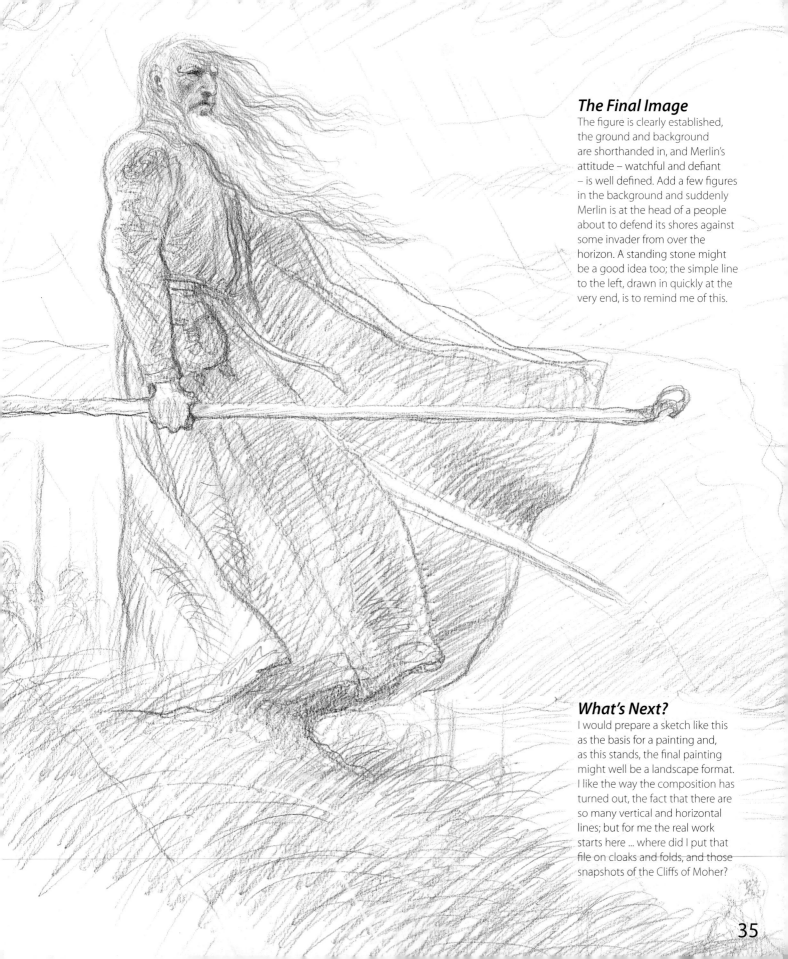

### The Final Image

The figure is clearly established, the ground and background are shorthanded in, and Merlin's attitude – watchful and defiant – is well defined. Add a few figures in the background and suddenly Merlin is at the head of a people about to defend its shores against some invader from over the horizon. A standing stone might be a good idea too; the simple line to the left, drawn in quickly at the very end, is to remind me of this.

### What's Next?

I would prepare a sketch like this as the basis for a painting and, as this stands, the final painting might well be a landscape format. I like the way the composition has turned out, the fact that there are so many vertical and horizontal lines; but for me the real work starts here ... where did I put that file on cloaks and folds, and those snapshots of the Cliffs of Moher?

# DWARF

Long-lived and strong, swarthy and long-bearded, dwarves are renowned as fine metal-smiths, tirelessly mining ore and fashioning weapons and armour in countless works of fantasy, from the oldest Norse myths to the deep delvings of Middle-Earth.

## Project techniques

- A basic fantasy portrait
- Facial detailing for personality
- Shading for depth and volume
- Using photos as inspiration

## Ideas and inspiration

'One dwarf please,' said my editor. 'Standard, dwarfish, you understand.'
'Of course,' I replied, although I didn't really. Yet, in the end, I thought it might be wise to steer away, even if only once, from the bearded, wrinkled, one-of-seven variety.

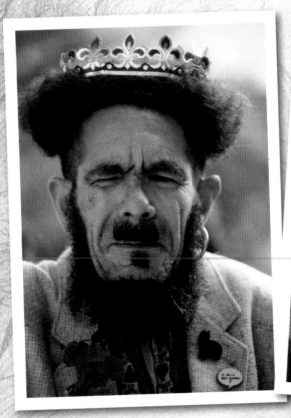

## Project references

I met this gentleman many years ago at a comics' festival and was struck by… well, you can easily see by the portraits he graciously allowed me to take. My editor's request was an opportunity to finally make use of these most unusual portraits. With such strong references there isn't really much need for a thumbnail sketch.

*The model has wonderful ears, so I plan to exaggerate these in the drawing, and to incorporate his extraordinary haircut and distinctive beard too.*

*A second portrait from a slightly different angle, although it's not necessarily going to be used directly.*

## Artist tip

It may be helpful to begin by drawing an oval for the face and dividing it with three well-placed lines for a guide to positioning the eyes, nose and mouth. See pages 20–23 for a basic step-by-step instruction on constructing a face.

**1** Working with a 4B pencil, start by lightly blocking out the main features. Roughly sketch in the eyebrows, the nose and the moustache. Then outline the face and strengthen the bridge and the edge of the nose.

Add a little more emphasis to the jaw line, and then begin on the ears. The model's extraordinary ears are even more exaggerated in the sketch.

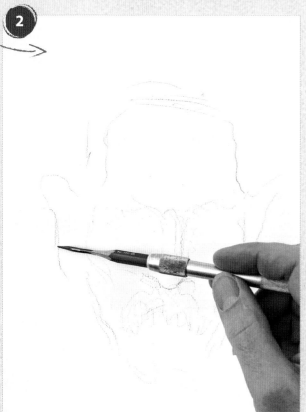

**2**

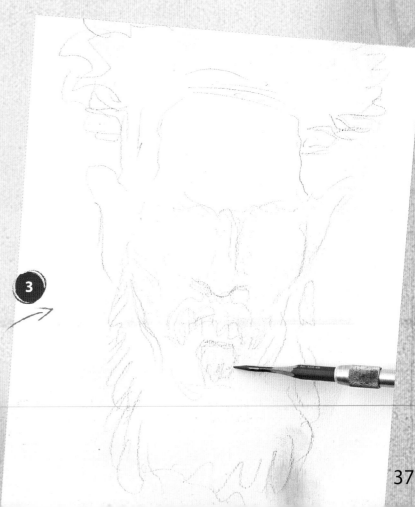

**3** Sketch the dwarf's hair as a large mass rising above his forehead. Return to the mouth area and establish the moustache, the tuft of hair on his chin and the shape of the beard. At this stage you are simply establishing the beard's volume and the final shape is defined later.

# DWARF

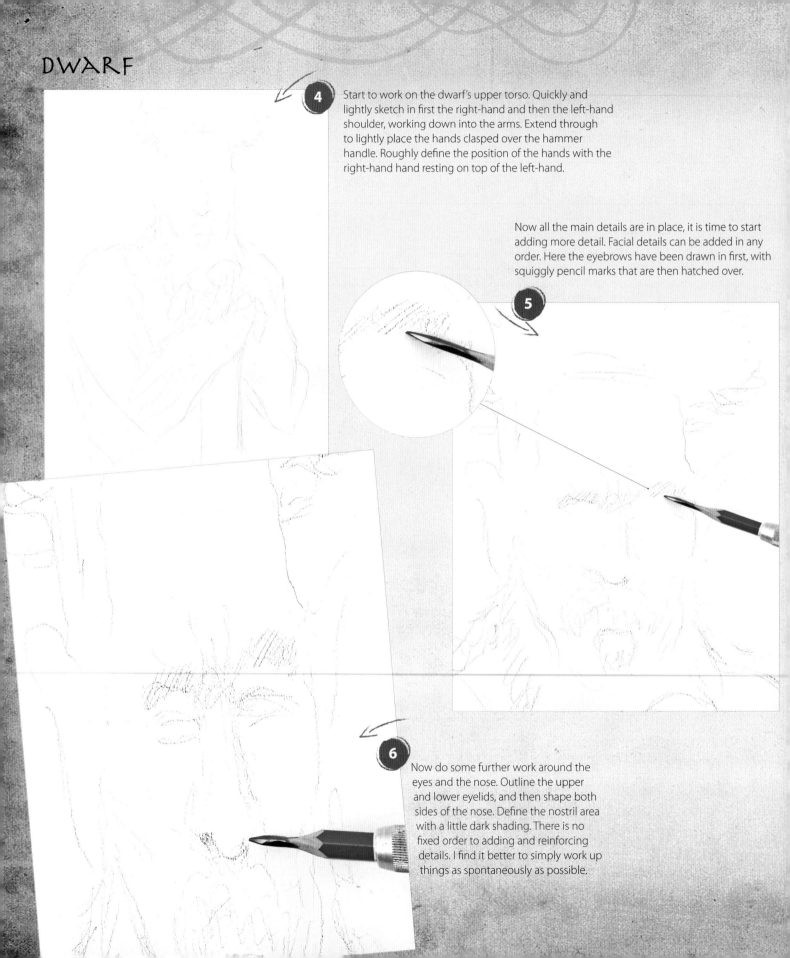

**4** Start to work on the dwarf's upper torso. Quickly and lightly sketch in first the right-hand and then the left-hand shoulder, working down into the arms. Extend through to lightly place the hands clasped over the hammer handle. Roughly define the position of the hands with the right-hand hand resting on top of the left-hand.

Now all the main details are in place, it is time to start adding more detail. Facial details can be added in any order. Here the eyebrows have been drawn in first, with squiggly pencil marks that are then hatched over.

**5**

**6** Now do some further work around the eyes and the nose. Outline the upper and lower eyelids, and then shape both sides of the nose. Define the nostril area with a little dark shading. There is no fixed order to adding and reinforcing details. I find it better to simply work up things as spontaneously as possible.

## Artist tip

The more enjoyable moments when sketching are unpremeditated, like the spontaneous development of the dwarf's long curly moustache. If you maintain a light hand you will be able to build on your own ideas as you go.

**7** Moving back to the mouth, fill in more of the moustache using short directional strokes to add volume above the upper lip. Extend the moustache by drawing long curly ends out from either side.

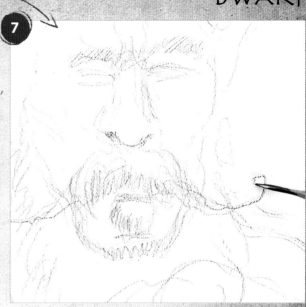

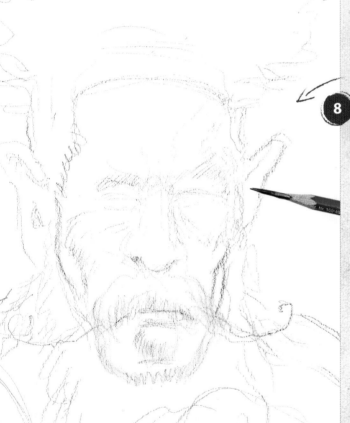

**8** Add in further detailing by cross-hatching on the moustache and then add further definition to the cheekbones with a firm pencil line. Work right up to firmly establish the contours around the forehead and the hairline. Then move back to the cheeks and add in some directional volume shading across the cheekbones (to create the furrows) and to the right-hand side of the forehead. Firmly establish the dwarf's right-hand ear.

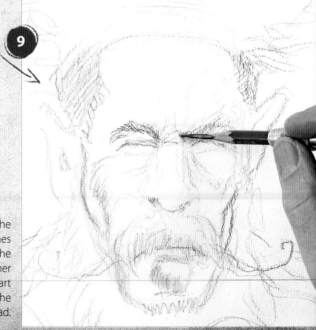

**9** Scribble in the hair on either side of the forehead. Use quick, clean, directional lines with some cross-hatching to establish the density. Move back to the eyes and add further emphasis to the eyebrows and eyes. Also start to establish wrinkles reaching up from the bridge of the dwarf's nose into his forehead.

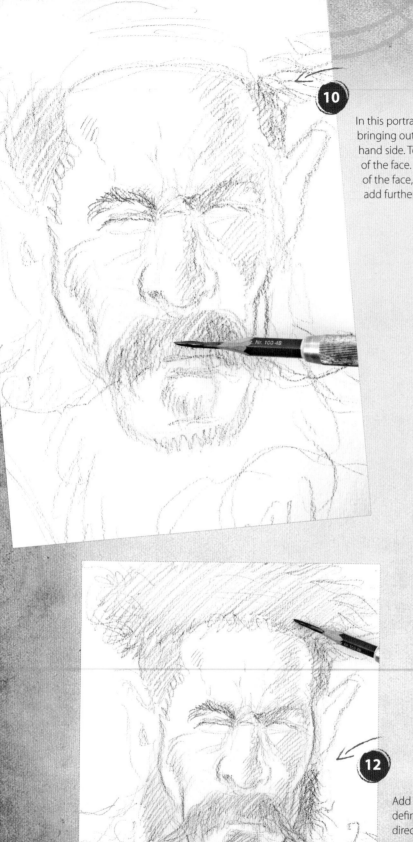

In this portrait the main light source is going to come from the left-hand side bringing out highlights from a secondary, weaker light source on the right-hand side. To establish this start to add to the shading on the right-hand side of the face. Use simple hatching, strengthening strokes to show the contours of the face, and shade down the right-hand side of the nose too. Darken and add further depth to the moustache.

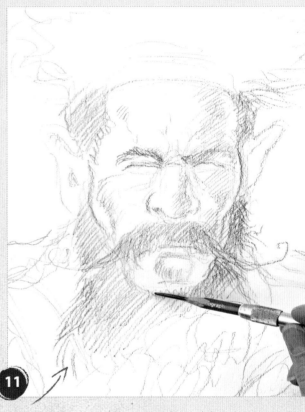

Continue to build up the moustache, and then start to add the beard around the sides of the chin. Start with the usual directional shading as shown on the left, and add volume and texture with more random pencil marks as shown on the right.

Add further shading on the chin tuft. Then define the outline of the head hair with broad directional strokes.

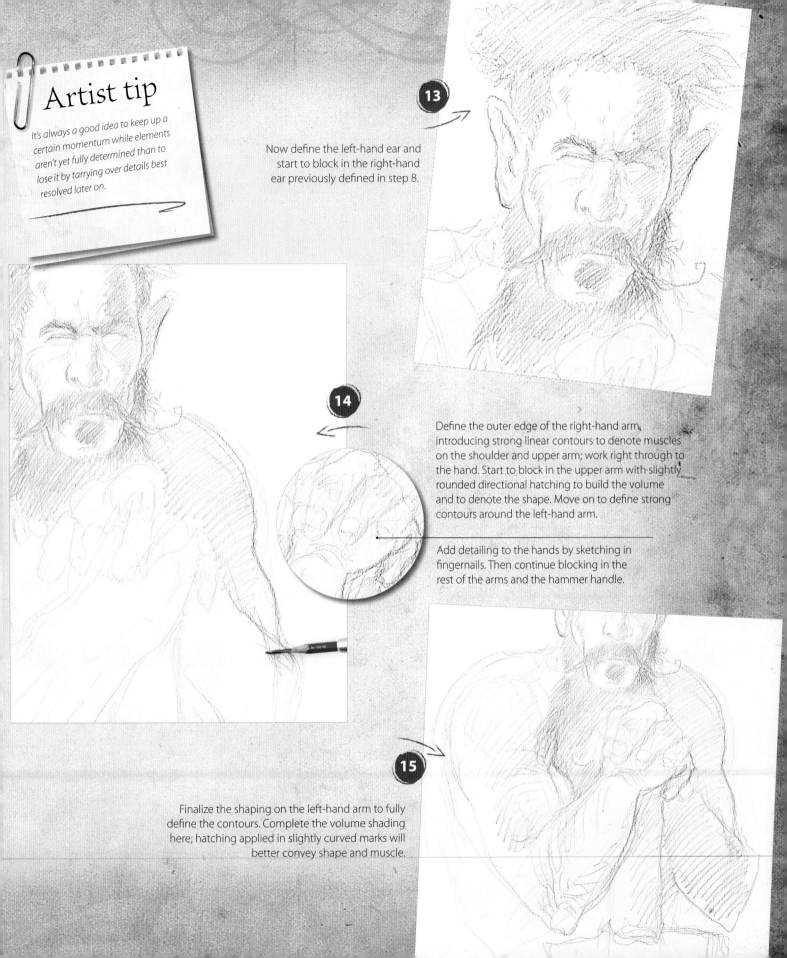

## Artist tip

It's always a good idea to keep up a certain momentum while elements aren't yet fully determined than to lose it by tarrying over details best resolved later on.

**13**

Now define the left-hand ear and start to block in the right-hand ear previously defined in step 8.

**14**

Define the outer edge of the right-hand arm, introducing strong linear contours to denote muscles on the shoulder and upper arm; work right through to the hand. Start to block in the upper arm with slightly rounded directional hatching to build the volume and to denote the shape. Move on to define strong contours around the left-hand arm.

Add detailing to the hands by sketching in fingernails. Then continue blocking in the rest of the arms and the hammer handle.

**15**

Finalize the shaping on the left-hand arm to fully define the contours. Complete the volume shading here; hatching applied in slightly curved marks will better convey shape and muscle.

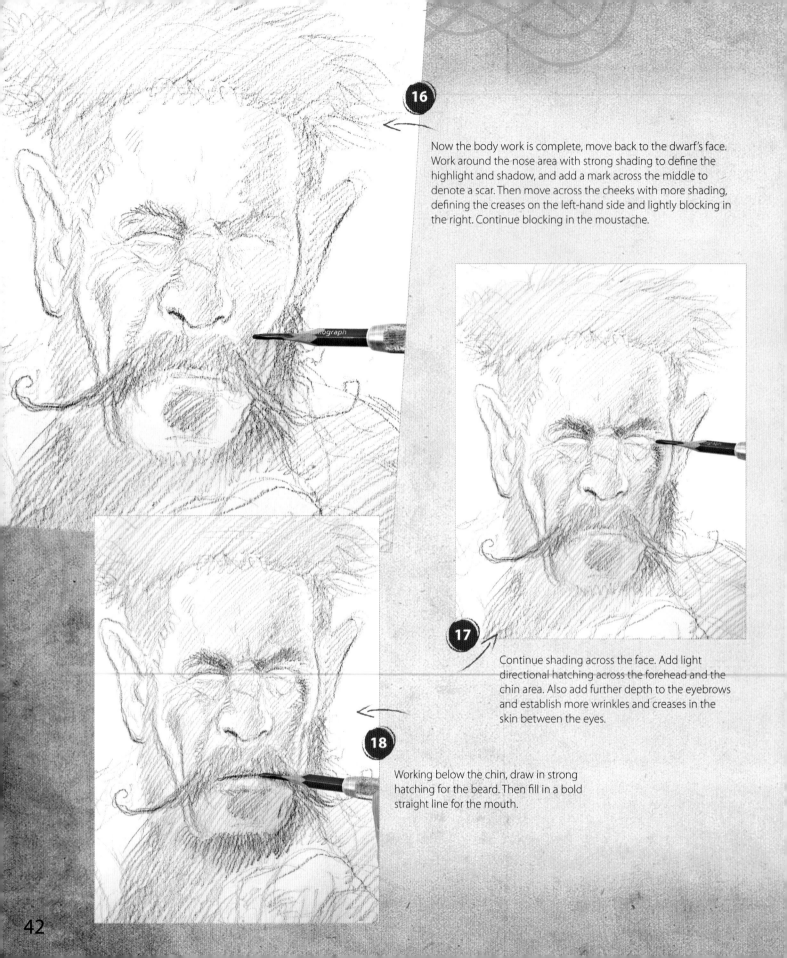

**16**

Now the body work is complete, move back to the dwarf's face. Work around the nose area with strong shading to define the highlight and shadow, and add a mark across the middle to denote a scar. Then move across the cheeks with more shading, defining the creases on the left-hand side and lightly blocking in the right. Continue blocking in the moustache.

**17**

Continue shading across the face. Add light directional hatching across the forehead and the chin area. Also add further depth to the eyebrows and establish more wrinkles and creases in the skin between the eyes.

**18**

Working below the chin, draw in strong hatching for the beard. Then fill in a bold straight line for the mouth.

Lightly shade the lower lip to give the impression of shape and volume. Add more cross-hatching on the chin tuft and beard to increase the texture. Now add in the dwarf's earring, leaving white paper to denote the highlight.

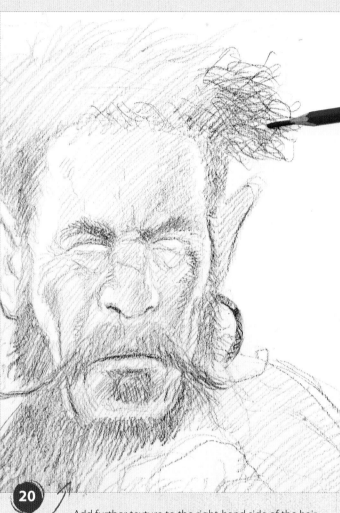

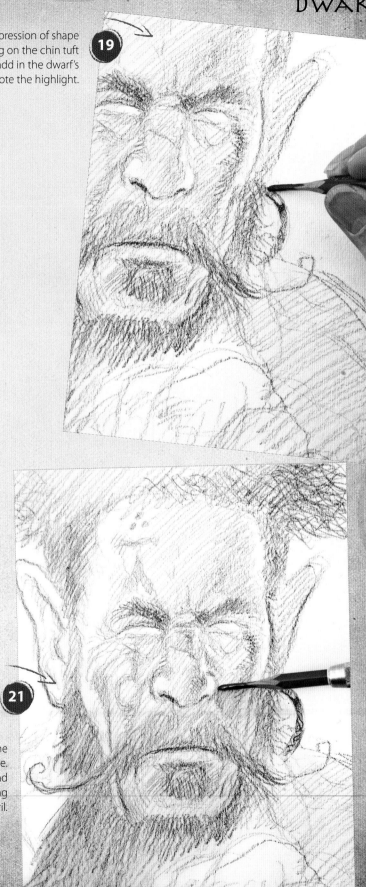

Add further texture to the right-hand side of the hair with strong squiggly lines. This is sufficient to give an impression of the hair's texture.

Now sketch in the suggestion of tattoos on the left-hand side of the face, above and below the eye. These can be developed further once you have had a chance to research suitable designs. Finish defining the bridge of the nose and right-hand nostril.

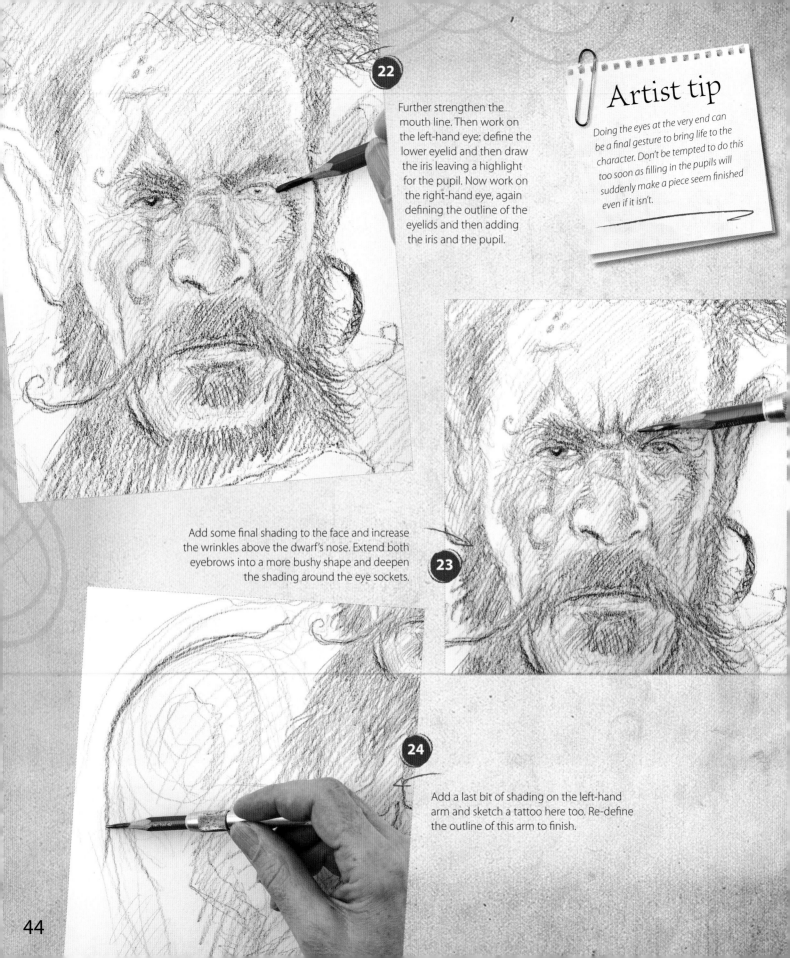

**22**

Further strengthen the mouth line. Then work on the left-hand eye: define the lower eyelid and then draw the iris leaving a highlight for the pupil. Now work on the right-hand eye, again defining the outline of the eyelids and then adding the iris and the pupil.

## Artist tip

Doing the eyes at the very end can be a final gesture to bring life to the character. Don't be tempted to do this too soon as filling in the pupils will suddenly make a piece seem finished even if it isn't.

Add some final shading to the face and increase the wrinkles above the dwarf's nose. Extend both eyebrows into a more bushy shape and deepen the shading around the eye sockets.

**23**

**24**

Add a last bit of shading on the left-hand arm and sketch a tattoo here too. Re-define the outline of this arm to finish.

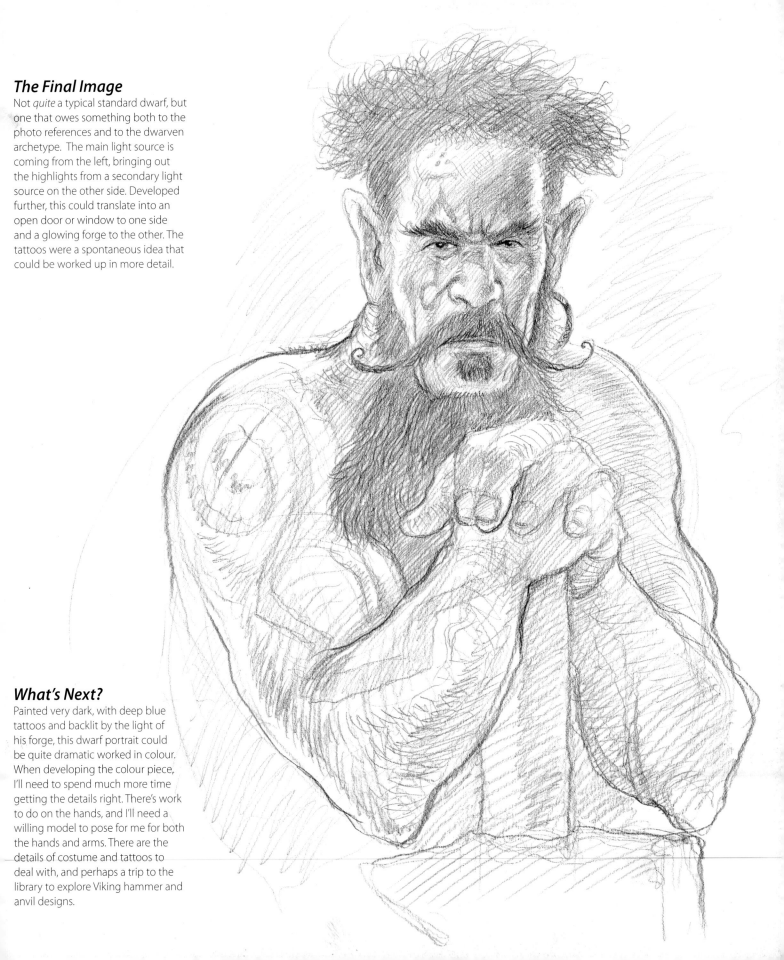

## The Final Image

Not *quite* a typical standard dwarf, but one that owes something both to the photo references and to the dwarven archetype. The main light source is coming from the left, bringing out the highlights from a secondary light source on the other side. Developed further, this could translate into an open door or window to one side and a glowing forge to the other. The tattoos were a spontaneous idea that could be worked up in more detail.

## What's Next?

Painted very dark, with deep blue tattoos and backlit by the light of his forge, this dwarf portrait could be quite dramatic worked in colour. When developing the colour piece, I'll need to spend much more time getting the details right. There's work to do on the hands, and I'll need a willing model to pose for me for both the hands and arms. There are the details of costume and tattoos to deal with, and perhaps a trip to the library to explore Viking hammer and anvil designs.

# DRAGON

This might best be described as the archetypal dragon (of St George and the dragon fame), with a storybook knight eagerly galloping to the fight. One might imagine he has shattered his lance on a first pass, and now must come in to rather closer (and possibly much warmer) quarters.

## Project techniques

- Design and form through contour
- Conveying energy and action

## Ideas and inspiration

I wanted to create a drawing that had an implied narrative. Who is the knight, why is he battling the dragon and what will happen? Graphically, though, the scene must be self-contained, concentrating on the action of the moment, rather than what has gone before or what will come after.

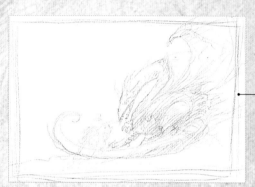

## Thumbnail sketch

A quick sketch was done to plan out the scene. This helps me to work out how the piece will work graphically within the page. The dragon's wing and tail 'contain' the image and help the viewer to stay in the moment, drawing the eye into the scene. I would work up this drawing as a prelude to a colour painting of the subject.

**1**

Working with a 4B pencil, sketch in the long, curved tail of the dragon. This will provide the initial building block on which the whole image will be developed. It's the most important part, despite what will be added later, so it should have a certain energy.

**2**

Now sketch the long neck of the dragon, forming a full backwards 's' shape where it curves around to become the creature's chest. Also start to sketch in the body. These lines need to work as pure lines since they are all about establishing the energy and movement rather than any particular physical detail.

**3**

Sketch in the foreleg and the haunch of the hind leg. Move on to the head and start to put in some structure here by sketching the dragon's open mouth and the various spikes and spines. Then work back into the neck, feeling out the shape here and adding some initial cross-hatching for volume and texture.

**4**

From the neck move up to further establish the shape of the wing. Then return to the neck and add some further contour shading. Begin to suggest the dragon's other foreleg with its raised clawed foot. Add crest around the curve of the neck. Move down to the tail: strengthen its shape and add a crest. Lightly sketch in the ground.

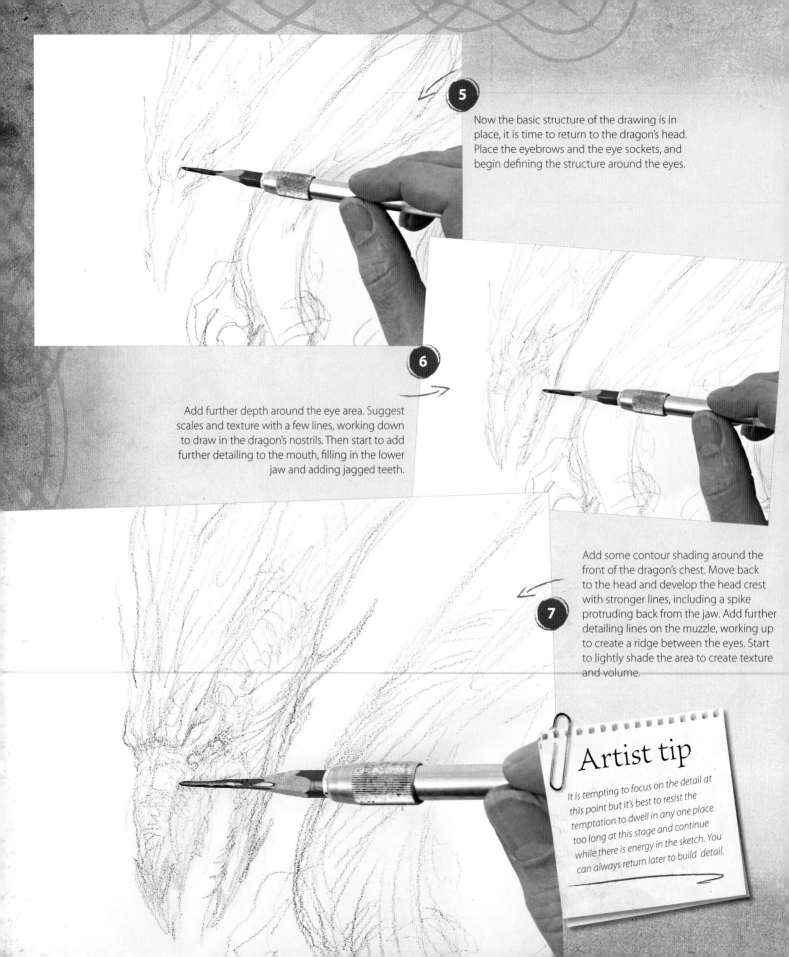

**5** Now the basic structure of the drawing is in place, it is time to return to the dragon's head. Place the eyebrows and the eye sockets, and begin defining the structure around the eyes.

**6** Add further depth around the eye area. Suggest scales and texture with a few lines, working down to draw in the dragon's nostrils. Then start to add further detailing to the mouth, filling in the lower jaw and adding jagged teeth.

**7** Add some contour shading around the front of the dragon's chest. Move back to the head and develop the head crest with stronger lines, including a spike protruding back from the jaw. Add further detailing lines on the muzzle, working up to create a ridge between the eyes. Start to lightly shade the area to create texture and volume.

## Artist tip

It is tempting to focus on the detail at this point but it's best to resist the temptation to dwell in any one place too long at this stage and continue while there is energy in the sketch. You can always return later to build detail.

**8**

Move into the neck and build up the texture and shape here by adding further cross-hatching. Establish the eye sockets further and apply further shading over the head to block it in. Work around the teeth with a bold line to create a strong, jagged edge.

**9**

Apply further shading on the chest area and reinforce the contour line here, working down into the foreleg. Start to shade in the foreleg, and sketch in the claw. Continue shading up into the chest and neck.

The neck of a dragon, like the body of a snake, is pure muscle. To capture the energy of the living creature do not think of an outline as a simple continuous line, but as a collection of lines appearing and disappearing around the volume they delineate.

**10**

Move up into the wing area, roughly establishing its shape. The wing is not represented in detail in this drawing but it is an important visual element which helps to contain dramatic effect within the image.

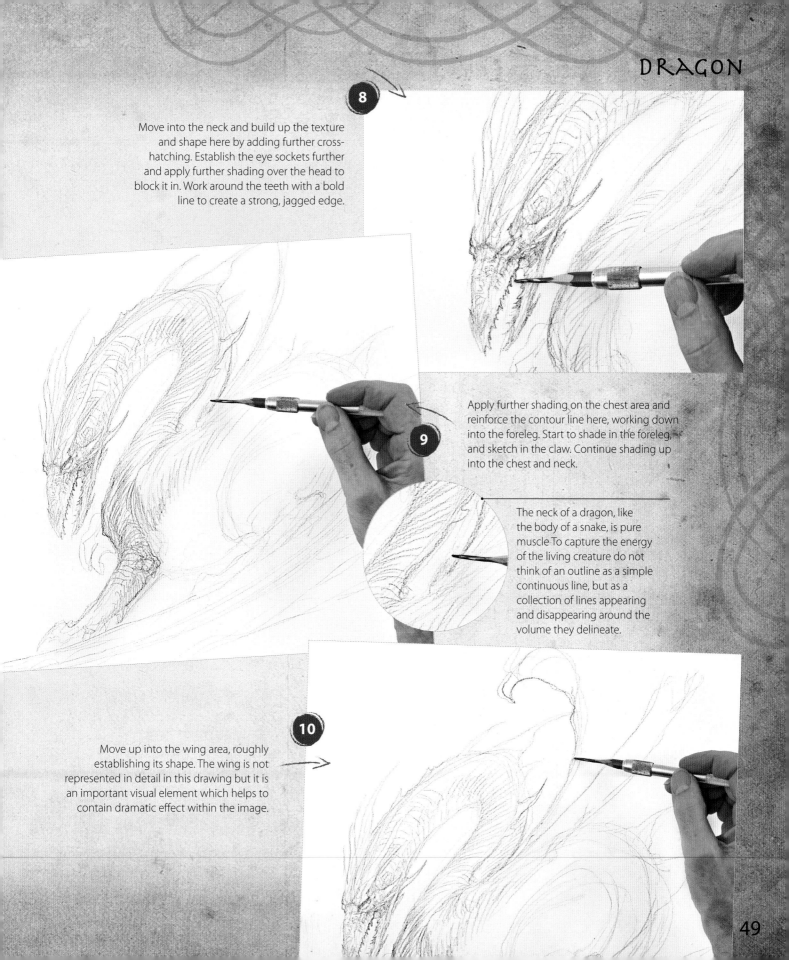

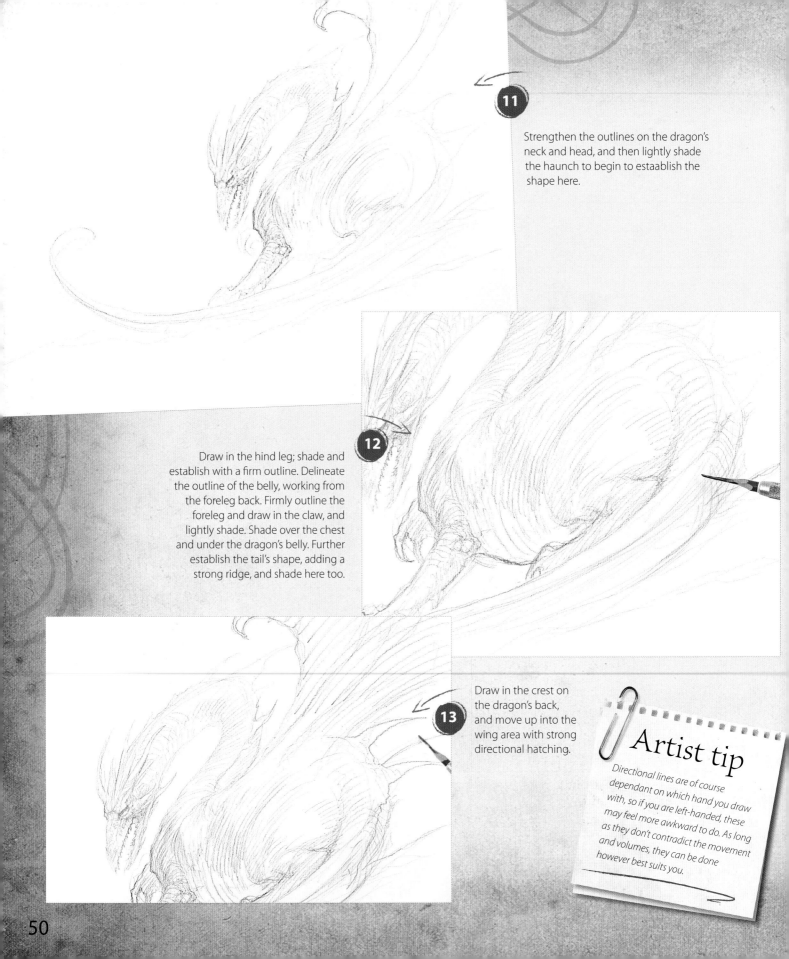

**11**

Strengthen the outlines on the dragon's neck and head, and then lightly shade the haunch to begin to estaablish the shape here.

**12**

Draw in the hind leg; shade and establish with a firm outline. Delineate the outline of the belly, working from the foreleg back. Firmly outline the foreleg and draw in the claw, and lightly shade. Shade over the chest and under the dragon's belly. Further establish the tail's shape, adding a strong ridge, and shade here too.

**13**

Draw in the crest on the dragon's back, and move up into the wing area with strong directional hatching.

## Artist tip

Directional lines are of course dependant on which hand you draw with, so if you are left-handed, these may feel more awkward to do. As long as they don't contradict the movement and volumes, they can be done however best suits you.

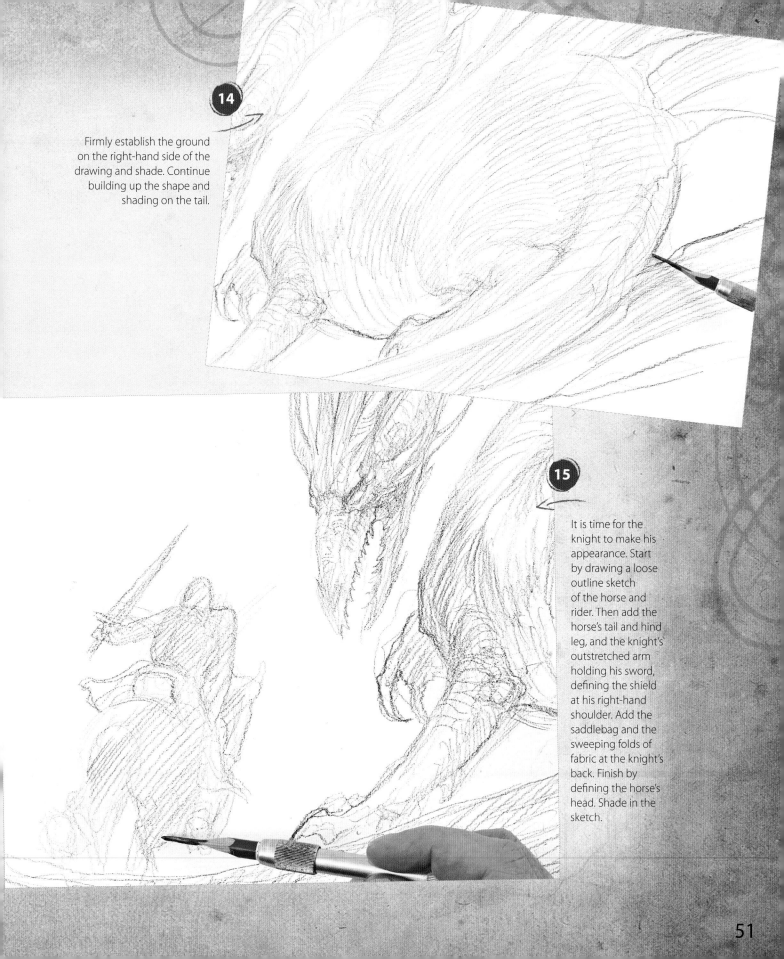

**14**

Firmly establish the ground on the right-hand side of the drawing and shade. Continue building up the shape and shading on the tail.

**15**

It is time for the knight to make his appearance. Start by drawing a loose outline sketch of the horse and rider. Then add the horse's tail and hind leg, and the knight's outstretched arm holding his sword, defining the shield at his right-hand shoulder. Add the saddlebag and the sweeping folds of fabric at the knight's back. Finish by defining the horse's head. Shade in the sketch.

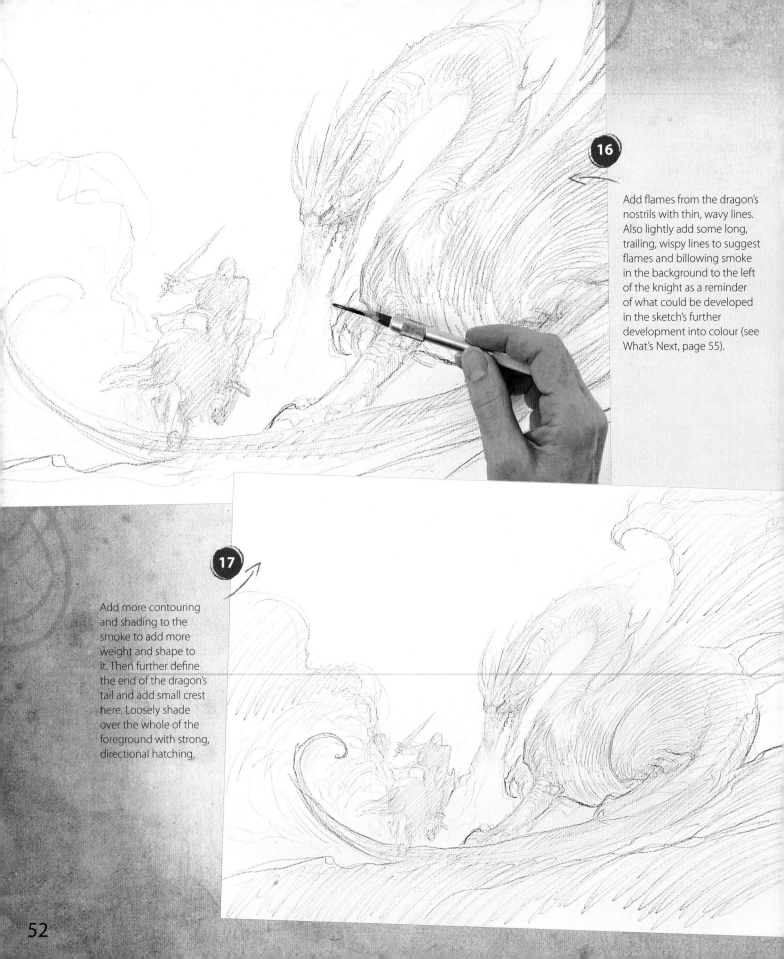

**16**

Add flames from the dragon's nostrils with thin, wavy lines. Also lightly add some long, trailing, wispy lines to suggest flames and billowing smoke in the background to the left of the knight as a reminder of what could be developed in the sketch's further development into colour (see What's Next, page 55).

**17**

Add more contouring and shading to the smoke to add more weight and shape to it. Then further define the end of the dragon's tail and add small crest here. Loosely shade over the whole of the foreground with strong, directional hatching.

Return to the dragon's head and add strong outlines to the eyes. Add some stronger markings around the forehead, and further define the ridges below the eyes. Add stronger lines down the muzzle to further build gnarled texture and then shade very lightly across the whole of the dragon's head.

**18**

Use a putty eraser to lighten the end of the muzzle to further enhance the impression of flames coming from the dragon's nostrils. (Sometimes it's easier to draw something in and then erase most of it than to draw it in faintly.)

**19** Add further contour lines across the muzzle, and up around the eyes and into the neck. Apply stronger outlines still to the crest and spines.

**20**

Again shade across the dragon's belly, this time with some cross-hatching to suggest the texture here. Then work down the tail with strong, short marks to enhance the volume and texture.

# DRAGON

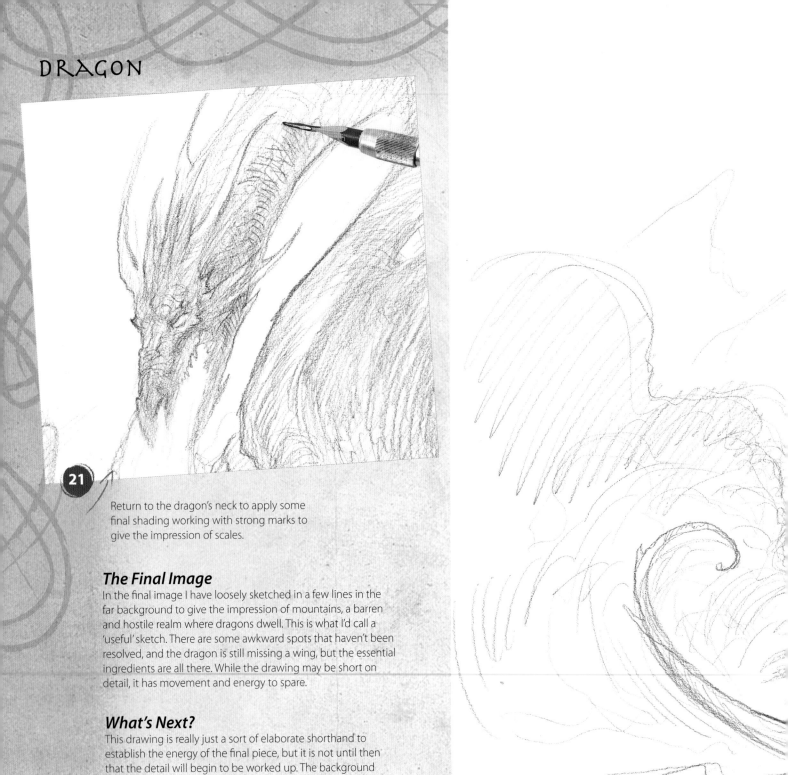

**21** Return to the dragon's neck to apply some final shading working with strong marks to give the impression of scales.

## The Final Image

In the final image I have loosely sketched in a few lines in the far background to give the impression of mountains, a barren and hostile realm where dragons dwell. This is what I'd call a 'useful' sketch. There are some awkward spots that haven't been resolved, and the dragon is still missing a wing, but the essential ingredients are all there. While the drawing may be short on detail, it has movement and energy to spare.

## What's Next?

This drawing is really just a sort of elaborate shorthand to establish the energy of the final piece, but it is not until then that the detail will begin to be worked up. The background will be developed, the knight will be properly realized, and the dragon will be rendered in all his reptilian glory with much more realistic scales. Drawing smoke and flames in pencil is a thankless task, but these elements will come to life in the colour piece. I will be glad that I did not spend too much time on the shape of the wing in the drawing, as in the final painting it is likely that the wing will be moving and therefore blurred.

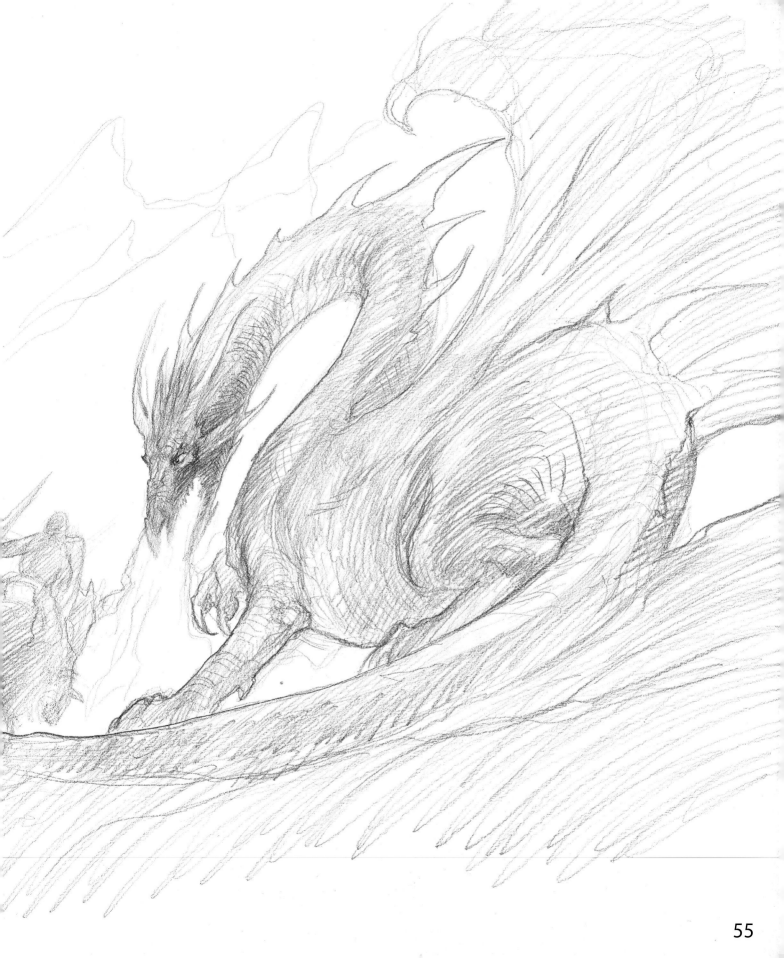

# THOR AND the GIANT

Thor, the Norse god of Thunder, persuades the giant Hymir to take him fishing, lopping the head off the giant's prized ox to serve as bait. He is after not just any fish, but Jörmungandr, the World-Encompassing Serpent, who sleeps beneath the Middle Sea, his tail held firmly in his mouth. When Jörmungandr takes the bait, a pretty agitated scene follows.

## Project techniques

- Drawing with energy
- Interaction of two characters
- Making a scene

## Ideas and inspiration

I wanted to depict these larger-than-life characters tossed upon stormy seas in a simple fishing boat, the giant battling to keep control against the massive, towering waves while Thor is engaged in an intense struggle of his own with his catch.

## Project references

For the Thor and the Giant sketch I dug out a number of pages cut out of a range of different magazines from my drawer marked 'Body – Male' to serve as reference. From male fashion advertising to body building articles, several came in useful as I progressed my ideas. For the fishing boat, reference to a good history book helped me to get the details right. Getting the detail right helps establish a reality for your imagined worlds.

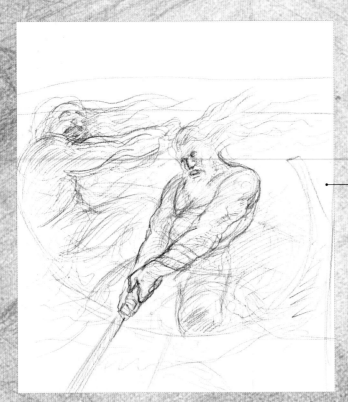

## Thumbnail sketch

A thumbnail is useful in these instances, where more than one figure must occupy a defined space. It can of course be much less elaborate than this. The thumbnail places the characters, and its tonal density gives some indication of the dramatic atmosphere that I hope to achieve in the final piece, but the full drama of the scene – the driving rain and the boat-tossing waves – has yet to be developed.

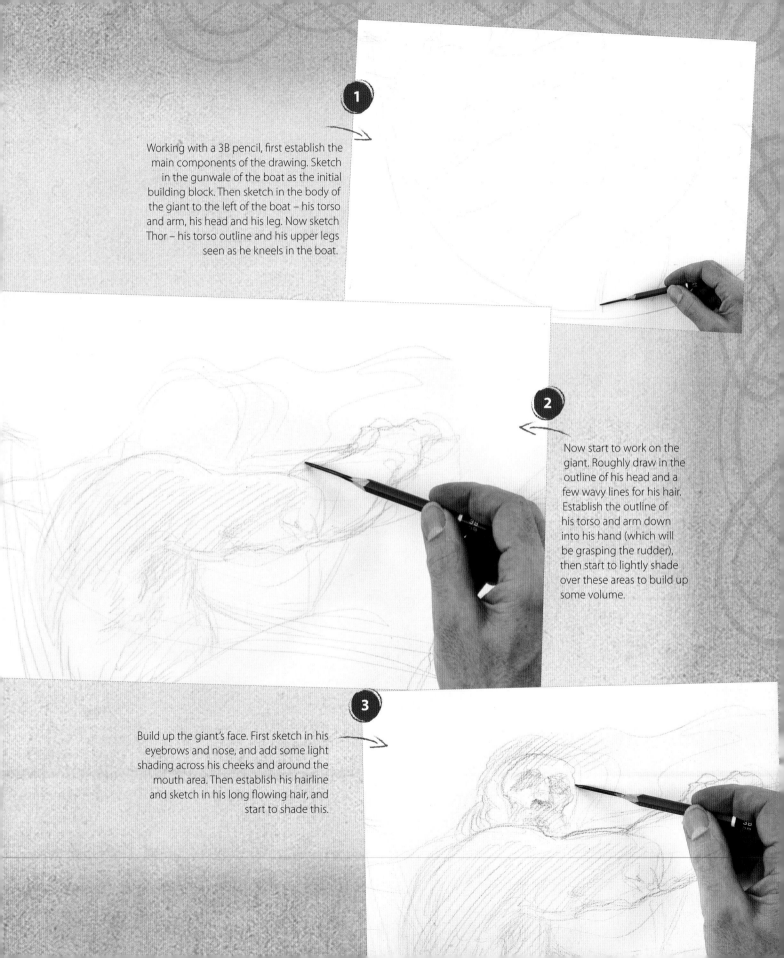

**1**

Working with a 3B pencil, first establish the main components of the drawing. Sketch in the gunwale of the boat as the initial building block. Then sketch in the body of the giant to the left of the boat – his torso and arm, his head and his leg. Now sketch Thor – his torso outline and his upper legs seen as he kneels in the boat.

**2**

Now start to work on the giant. Roughly draw in the outline of his head and a few wavy lines for his hair. Establish the outline of his torso and arm down into his hand (which will be grasping the rudder), then start to lightly shade over these areas to build up some volume.

**3**

Build up the giant's face. First sketch in his eyebrows and nose, and add some light shading across his cheeks and around the mouth area. Then establish his hairline and sketch in his long flowing hair, and start to shade this.

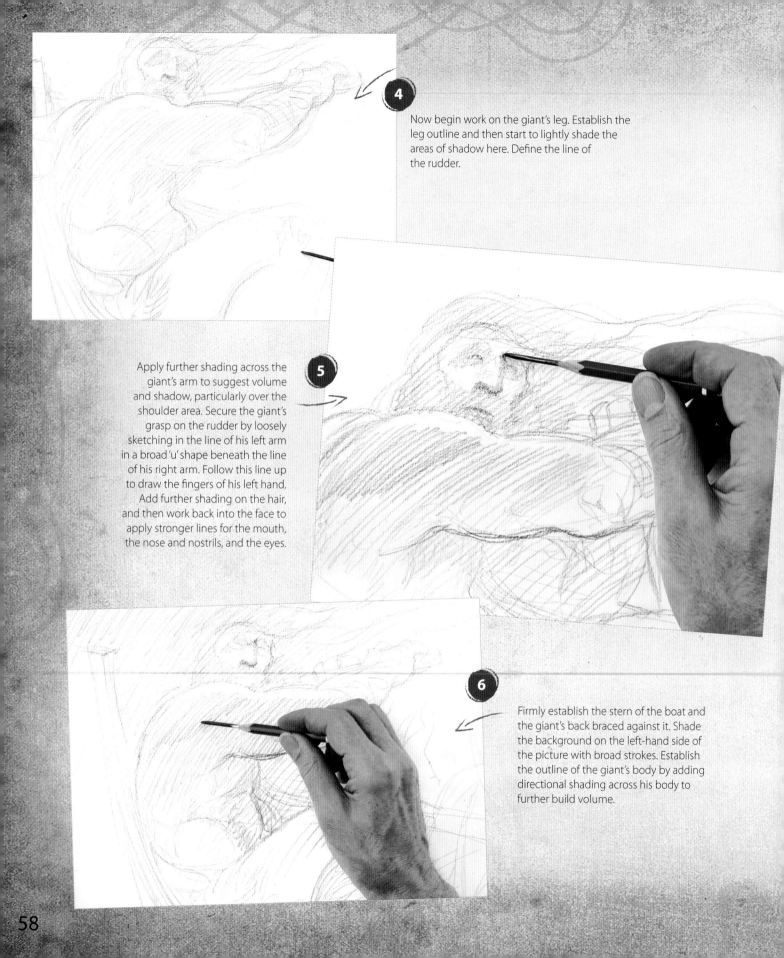

**4**

Now begin work on the giant's leg. Establish the leg outline and then start to lightly shade the areas of shadow here. Define the line of the rudder.

**5**

Apply further shading across the giant's arm to suggest volume and shadow, particularly over the shoulder area. Secure the giant's grasp on the rudder by loosely sketching in the line of his left arm in a broad 'u' shape beneath the line of his right arm. Follow this line up to draw the fingers of his left hand. Add further shading on the hair, and then work back into the face to apply stronger lines for the mouth, the nose and nostrils, and the eyes.

**6**

Firmly establish the stern of the boat and the giant's back braced against it. Shade the background on the left-hand side of the picture with broad strokes. Establish the outline of the giant's body by adding directional shading across his body to further build volume.

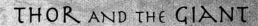

Use a strong pencil line to strengthen the outline of the giant's right arm and hand gripped around the rudder. Also firmly establish the giant's left hand alongside. Define the mouth adding strong shading around it to suggest a moustache and beard. Add pupils to the eyes and then work out to clearly establish the cheekbones. Continue shading across the body and the background.

**7**

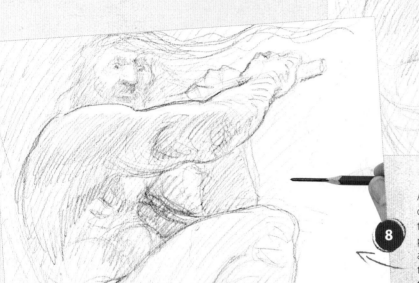

**8**

Add to and strengthen the wavy lines that convey the giant's flowing hair. Firmly establish the giant's leg and continue to shade his body, particularly on his torso and arm to build shape and volume here. This shading should define the muscles down the right arm and across the body and begin to define the giant's partly hidden left arm. Continue to build up the shading in the background, now moving to the right of the giant.

Shade a shadow down the inside of the boat's stern, and following the line of the free-flowing hair, continue to draw in broken wavy lines to the left and the right to give the impression of the sea's waves. Returning to the giant's face, increase the shadowing around the eye socket to give the impression of raised eyebrows. Use a putty eraser to knock back the facial details and clean up the hair across the forehead. Shade the mouth. Increase the shading in the hair to enhance the thickness.

**9**

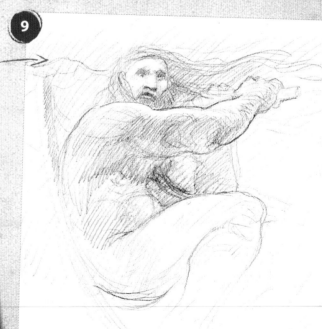

## Artist tip

I re-drew the mouth. If you got it right the first time, there is no need for you to do so. However, I find that it is tempting to over-define recognizable elements in a face, so I often erase facial details and work them over more freely.

# THOR AND THE GIANT

Now it's time to work on Thor. Start by establishing the shoulder and the right-hand arm, and then build up the left-hand arm and torso. Lightly shade, and draw the line of his back and midsection.

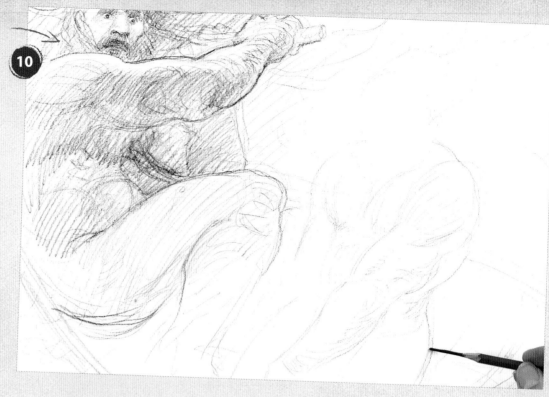

Apply further shading on Thor's upper chest to define his straining muscles as his tug-of-war with the serpent begins. Then start work on his head. Use guidelines to establish the head angle, and lightly sketch the outline of the skull.

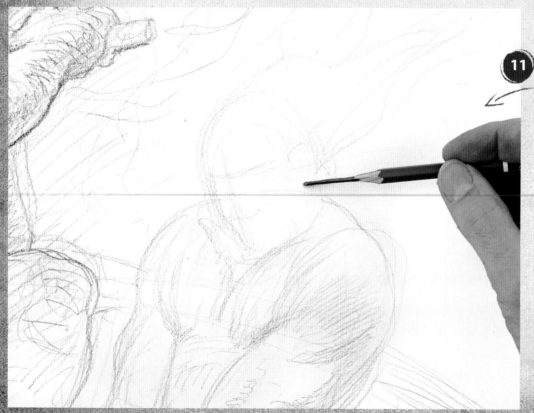

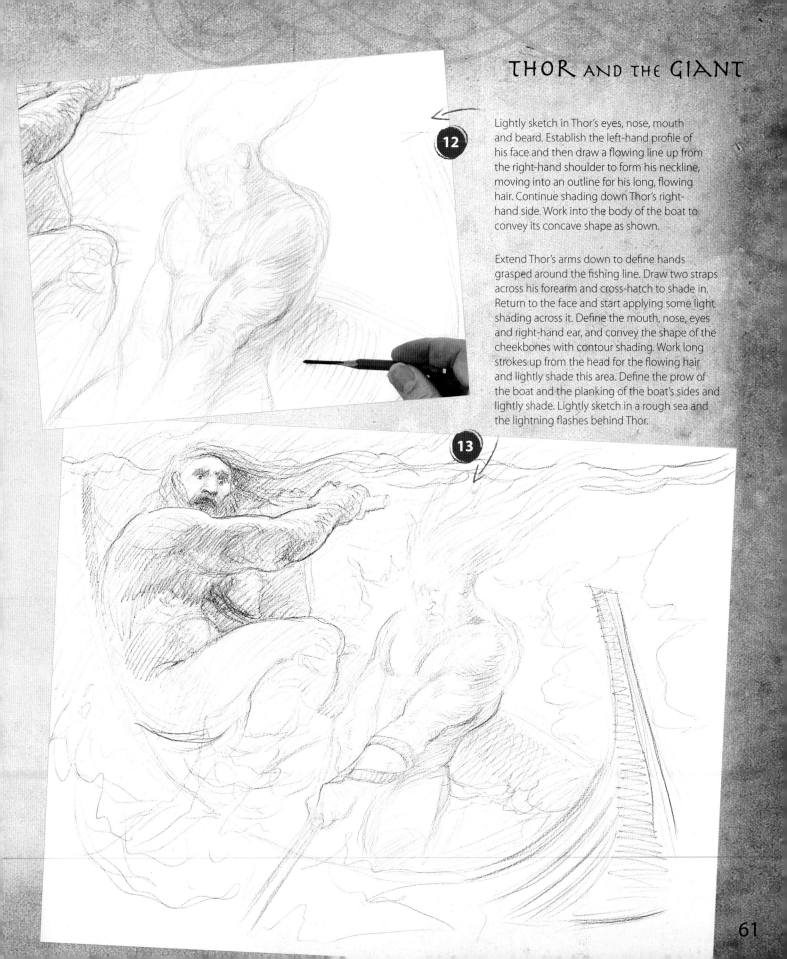

**12** Lightly sketch in Thor's eyes, nose, mouth and beard. Establish the left-hand profile of his face and then draw a flowing line up from the right-hand shoulder to form his neckline, moving into an outline for his long, flowing hair. Continue shading down Thor's right-hand side. Work into the body of the boat to convey its concave shape as shown.

Extend Thor's arms down to define hands grasped around the fishing line. Draw two straps across his forearm and cross-hatch to shade in. Return to the face and start applying some light shading across it. Define the mouth, nose, eyes and right-hand ear, and convey the shape of the cheekbones with contour shading. Work long strokes up from the head for the flowing hair and lightly shade this area. Define the prow of the boat and the planking of the boat's sides and lightly shade. Lightly sketch in a rough sea and the lightning flashes behind Thor.

**13**

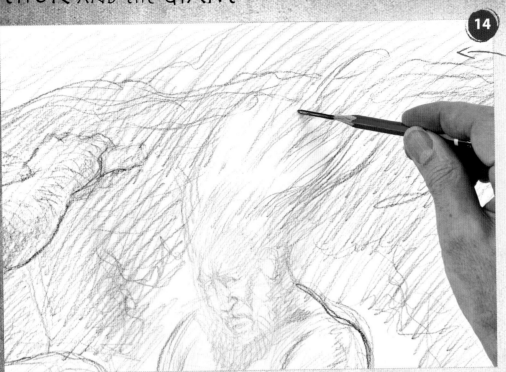

**14**

Apply bold shading across the whole of the sea area, and then add in some more waves to really build the dramatic backdrop of the scene. Use an eraser to lift Thor's hair out from the shaded area, and re-define his flowing hair strands.

## Artist tip

On a rough sketch like this, you might as well let go and work vigorously. Occasionally, you will find energy in unexpected lines and vigorous shading. Never be afraid to 'go for it' if you feel you might capture something. You can always erase and draw it again.

Add further definition to the outline of Thor's arms and torso, and then move back to work on his face. Further define his beard, mouth and nostrils, and start to apply the creases on either side of his mouth.

**15**

**16**

Add further texture on Thor's moustache and beard, and then further define his left-hand profile, shading here to convey shadow. Add raised eyebrows to convey his exertion, and then fill in the pupils. Working up full details in faces that will eventually be painted in colour isn't always necessary of course, but faces with dramatic and well-defined expressions – in this case teeth-gritting determination and fear – are always worth exploring.

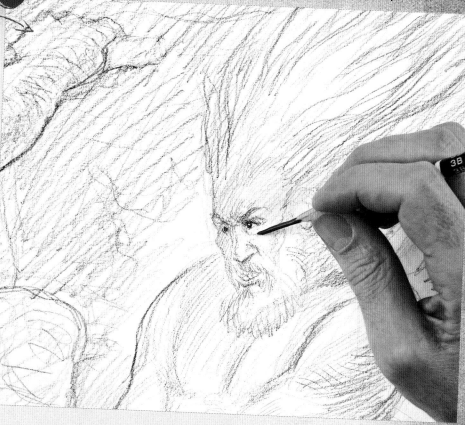

**17**

Work a line of contour shading down the right-hand side of Thor's face to define his cheek, and further develop his moustache and the edge and volume of his beard with strong shading. Also work on the shaping of his ear.

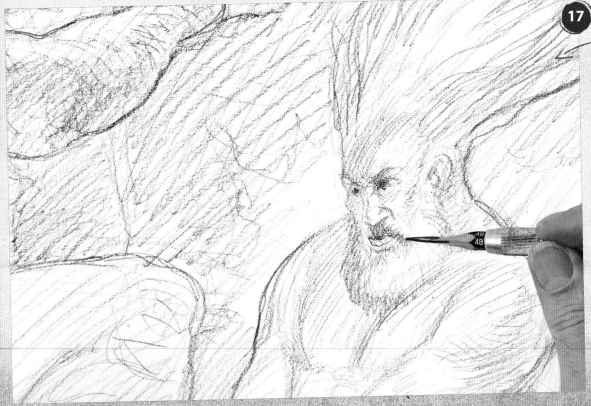

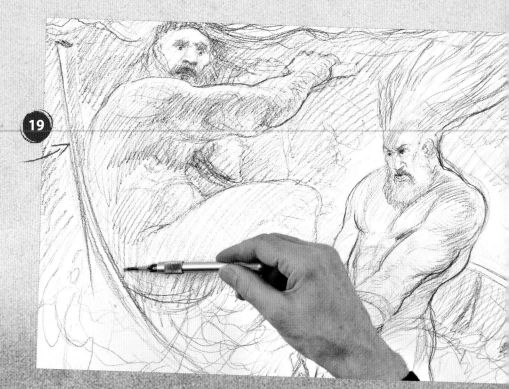

## Artist tip

Refer often to your source material. Ensuring authenticity of period objects and historical details in a sketch will help to establish credibility for the imagined characters.

**18**

Re-define the outline of Thor's arms. Now spend some time ensuring the boat details are as authentic as possible. Define the boat edges, the stern and the prow. Add detail inside the boat too using shading to define the planks and the ribs.

**19**

Add sheets of rain across the image in bold directional strokes from left to right. Continue shading the background and add more hair lines to both characters so that they appear to merge with the waves. Return to the giant and build up more bold shading on his body to begin to balance out the sketch.

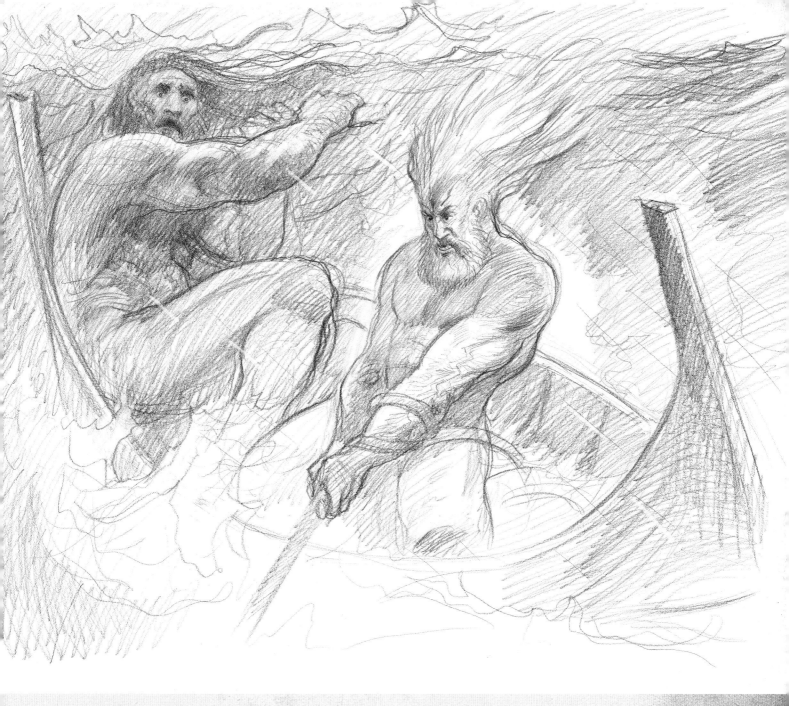

### The Final Image

This drawing succeeds in capturing a fair bit of the
energy and tension that I was looking for. Still quite a
rough sketch, with little in the way of worked up details, the
final image more than adequately defines the dark wall of
water behind and Thor lit up by lightning and makes a very
atmospheric piece.

### What's Next?

I look forward to developing this into a colour painting.
The wall of water and the storm clouds running
diagonally across the sky will be enormous fun to
paint, and the foam and spray will offer loads of
possibilities for contrast. Thor might be a little on the
big side though, compared to the giant, so I'll likely
reduce him slightly.

# LANCELOT

Lancelot has become, over many retellings of the legend of King Arthur, a complex and intriguingly flawed character. The greatest and most trusted of the king's knights, Lancelot's flight to France with Queen Guenevere precipitates the fall of Camelot and the end of Arthur's kingdom.

## Project materials

- Derwent pastel pencils: white, light blue, terracotta, light terracotta, umber, light violet
- Blue-grey cartridge paper

## Project techniques

- Introducing pastel pencils
- Drawing armour
- Working with highlights and shadow

## Ideas and inspiration

I wanted to show Lancelot on his ship in a pensive mood, perhaps a sorrowful look back to home shores, and contemplating the gathering clouds on the far horizon. Also, I have a confession to make: I have never used coloured pencils on coloured paper, so this is a bit of an experiment.

## Graphite pencil sketch

This is a preliminary pencil sketch that didn't capture what I was after very well, but did serve to eliminate a few things which would not have functioned in a larger sketch. Trying to concentrate too much on the armour to the detriment of Lancelot's profile was an error. Both need to be treated equally.

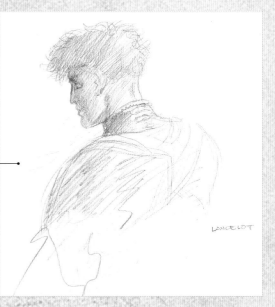

LANCELOT

## Project references

I have quite a collection of armour photographs I can call on to get the detailing right - postcards, posters and photographs I have taken myself. All the time spent looking at period costume, armour and weaponry, or visiting museum exhibitions if the opportunity arises, is time well spent. It can also be a constraint of sorts of course, if the need for precise documentation overshadows your freedom of imagination, so it's often wise to leave historically inspired details to one side until you've captured the spirit of your piece. For Lancelot himself, consulting pages of male models cut from fashion magazines over the years helped me to capture that wistful look I was aimin for.

With **terracotta**, establish Lancelot's basic outline. Start with the shape across the shoulders then work up into the jaw line. Place the profile and then work up into the hair area, establishing the hairline. Lightly shade across the cheek and then work down from the hair to form the smooth curve of the neck. Now you are ready to begin shading.

With **white** shade a clear highlight down the left-hand shoulder, then lightly apply white shading in broad strokes across the shoulder. Start blending this initial shading with **light blue**, as shown.

## Artist tip

*When building up blending with two colours, it helps to be able to hold both pencils in one hand as shown.*

Start to slowly build up the colour by blending the two pencils, adding a strong **white** highlight on the top of the shoulder. To emphasize the ridge of the shoulder armour, pull a putty eraser through the shading. As the colours are lightly applied – the weight of the pencil itself is almost enough to leave a line – you will have no trouble 'drawing' a clean line with the eraser. You will need to re-shape the eraser between strokes to keep the line clean and sharp.

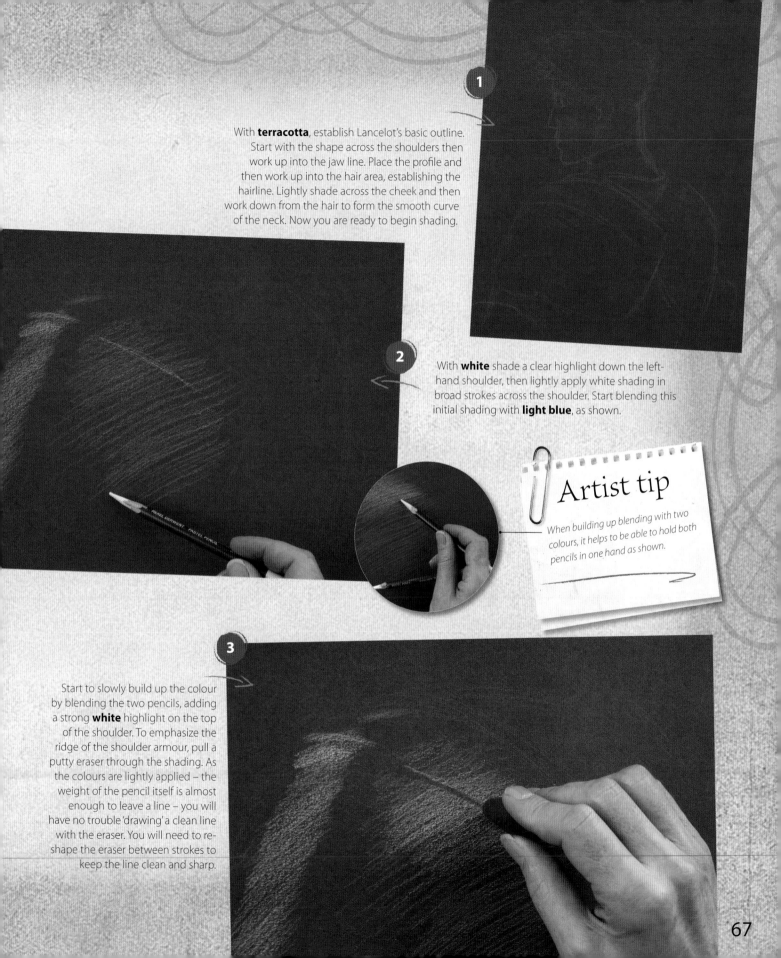

Continue one directional shading with **light blue** down the back of the shoulder. Increase the depth of shading on the edge of the shoulder with **white** and draw contour lines to denote the armour plating. Add a white edge to the terracotta outline around the pauldron (shoulder plate) and the couter (elbow guard).

**4**

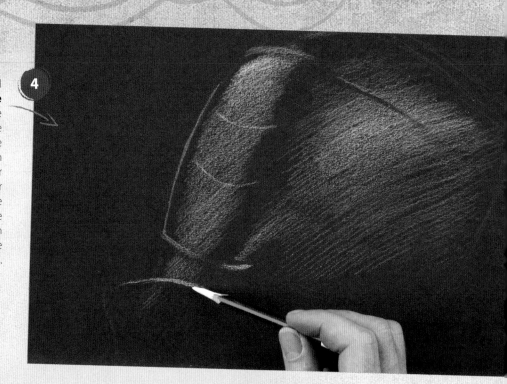

**5**

Continue with white directional shading down the back. Mark a defined line across the top of the shoulder for the stop rib. Erase small round marks at equal intervals along this line and fill with small white dots to create rivets.

## Artist tip

To draw armour effectively, it helps to know a little of how it is constructed and the purpose of the component parts. Rivets, for example, are not there just for decoration. Here they hold the stop rib in place. The purpose of this thin metal bar is to prevent the point of a weapon sliding into a joint or opening.

Continue shading with white down the shoulder, now cross-hatching across the original shading to create highlights. Add white highlights at the neck edge of the pauldron, and start to shade into the 'v' shape. This is where the back plates of the pauldrons overlap. Switch to **light blue** to fill in at the top of this area, and then shade down the right-hand shoulder with rounded directional shading.

**6**

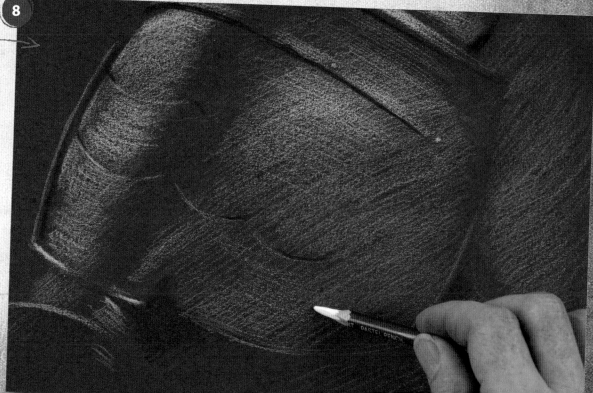

**7** Now with **umber**, lightly shade the area at the base of the pauldrons. Use the umber pencil to go over the terracotta outlines on the left-hand pauldron.

**8**

Switch back to **white**, and shade with rounded contour strokes down the left-hand edge of the pauldron. Add a stronger highlight to the lower edge, and then continue to build up shading using the white.

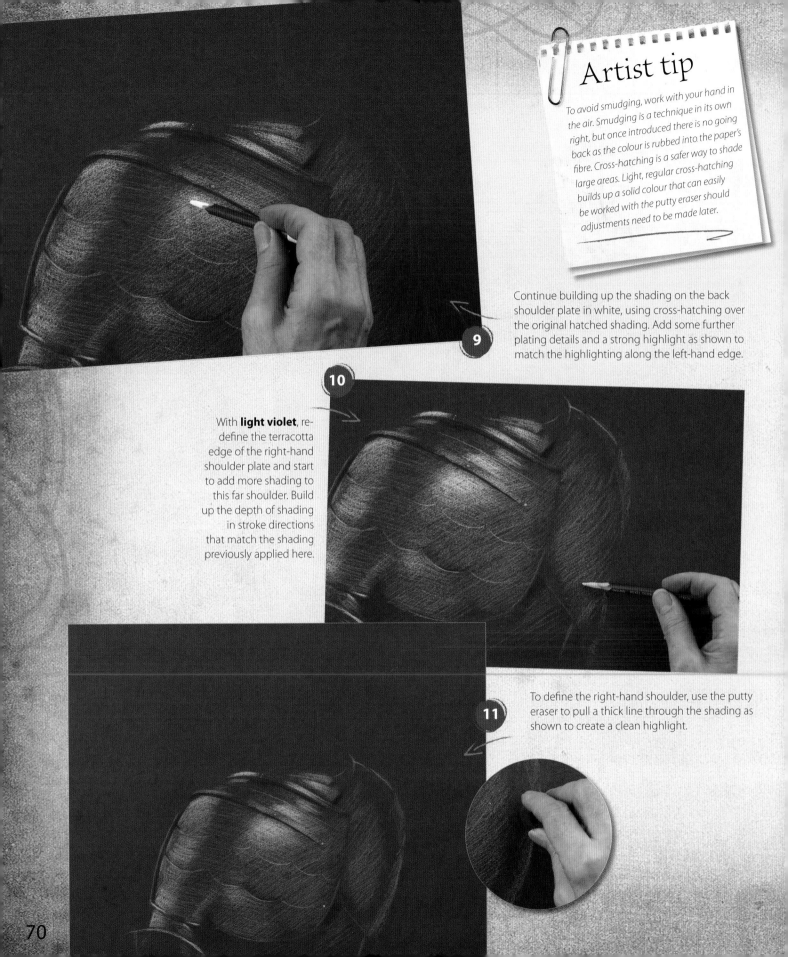

**9** Continue building up the shading on the back shoulder plate in white, using cross-hatching over the original hatched shading. Add some further plating details and a strong highlight as shown to match the highlighting along the left-hand edge.

**10** With **light violet**, re-define the terracotta edge of the right-hand shoulder plate and start to add more shading to this far shoulder. Build up the depth of shading in stroke directions that match the shading previously applied here.

**11** To define the right-hand shoulder, use the putty eraser to pull a thick line through the shading as shown to create a clean highlight.

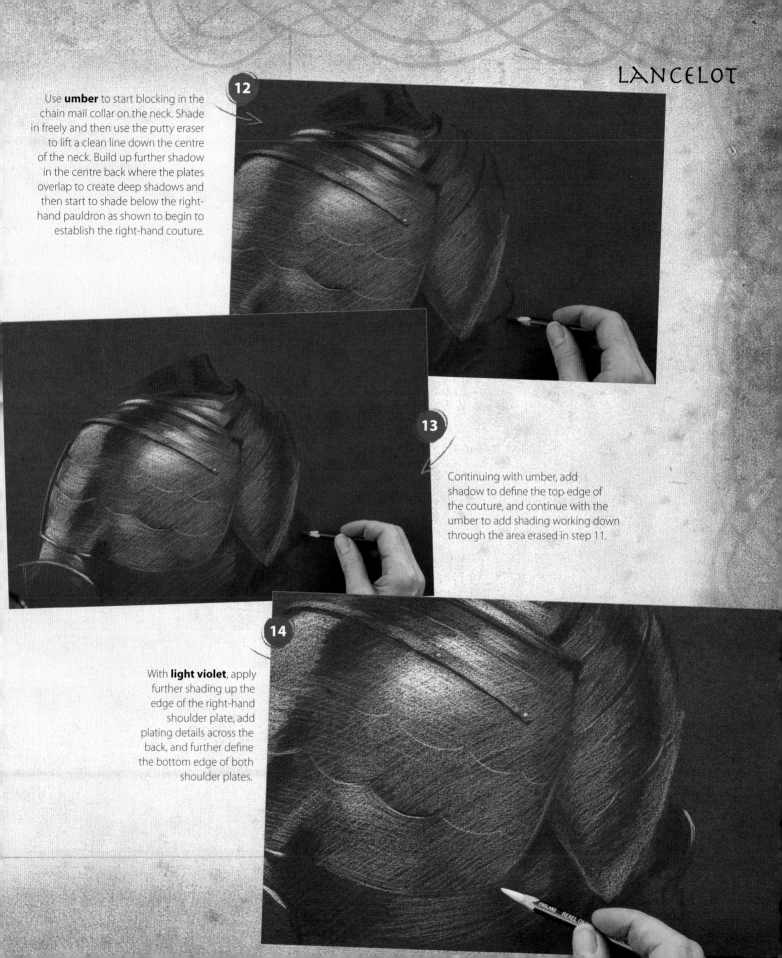

**12** Use **umber** to start blocking in the chain mail collar on the neck. Shade in freely and then use the putty eraser to lift a clean line down the centre of the neck. Build up further shadow in the centre back where the plates overlap to create deep shadows and then start to shade below the right-hand pauldron as shown to begin to establish the right-hand couture.

**13** Continuing with umber, add shadow to define the top edge of the couture, and continue with the umber to add shading working down through the area erased in step 11.

**14** With **light violet**, apply further shading up the edge of the right-hand shoulder plate, add plating details across the back, and further define the bottom edge of both shoulder plates.

# LANCELOT

**15**

Time to return to Lancelot's face. Using **light terracotta**, shade in the nose and cheek. Apply a small amount of **terracotta** to the cheekbone, and continue to shade with the **light terracotta**, gently blending the two colours on contact.

**16**

Use the light terracotta to shade down into the upper neck area, then switch back to the **terracotta** to re-define the profile outline and to shade below the chin and the cheek.

**17**

With **umber**, shade the hairline just above the eye, then the eyebrow, the lower eyelid and nostrils, the mouth and the chin.

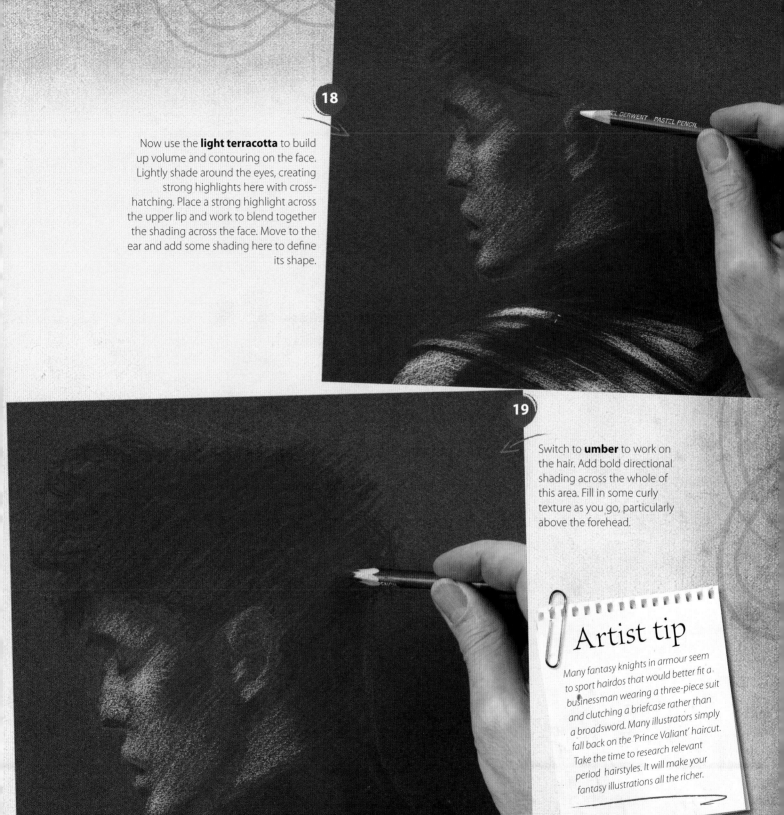

**18**

Now use the **light terracotta** to build up volume and contouring on the face. Lightly shade around the eyes, creating strong highlights here with cross-hatching. Place a strong highlight across the upper lip and work to blend together the shading across the face. Move to the ear and add some shading here to define its shape.

**19**

Switch to **umber** to work on the hair. Add bold directional shading across the whole of this area. Fill in some curly texture as you go, particularly above the forehead.

## Artist tip

Many fantasy knights in armour seem to sport hairdos that would better fit a businessman wearing a three-piece suit and clutching a briefcase rather than a broadsword. Many illustrators simply fall back on the 'Prince Valiant' haircut. Take the time to research relevant period hairstyles. It will make your fantasy illustrations all the richer.

# LANCELOT

**20**

To build up the detailing on the chain mail collar use **white** and **light blue** alternately in short curved marks in the space between the shaded areas.

**21**

With **terracotta**, thicken the outline on the base of the chin and around the nose. Then add some textural detailing at the front of the hair.

Highlight the eye by applying first terracotta, and then a spot of **light terracotta**. Then use **umber** to deepen the shadow of the eye socket.

**22**

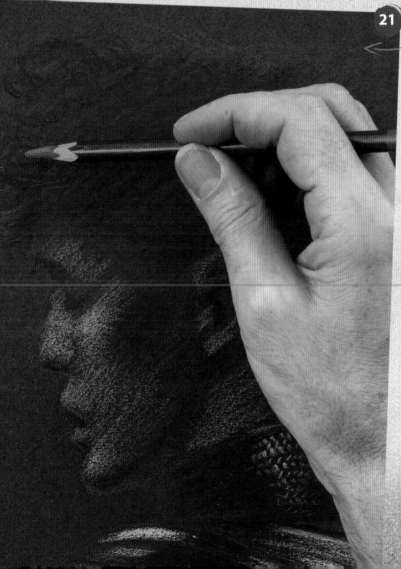

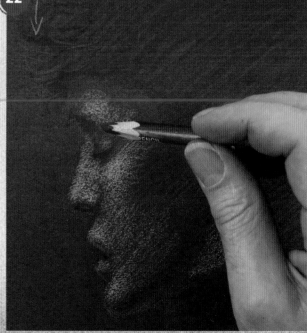

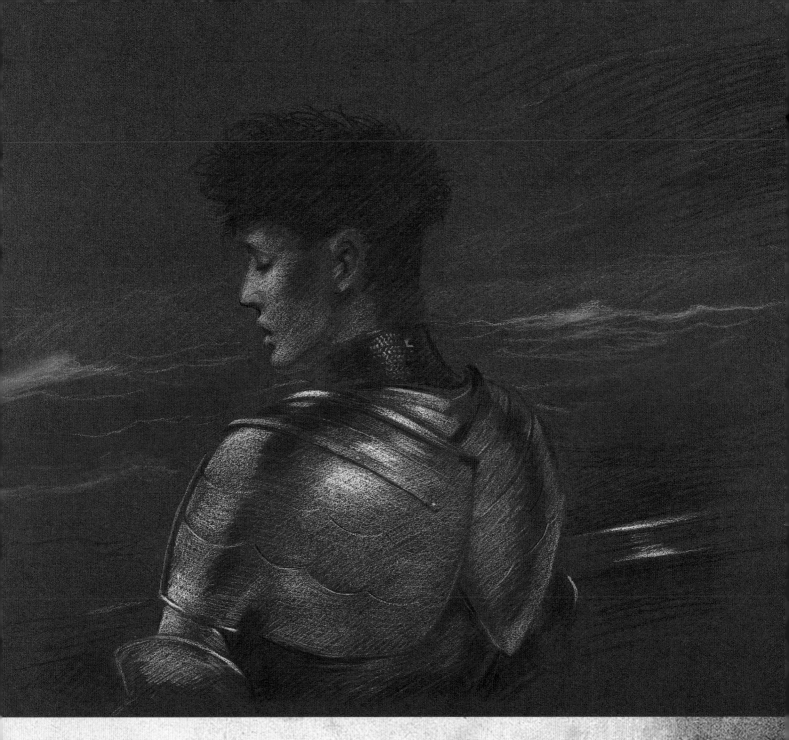

## The Final Image

For the final image I have added a background of stormy seas. The heavy waves are a metaphor for Lancelot's inner turmoil. Sketch in the waves with **light blue**, **white** and **violet**. For the sky, shade these colours plus **umber** and lightly smudge with your fingertips to blend. This is sufficient to define the atmosphere without drawing the attention away from the figure. I also added the gunwale of the boat with a few lines in **umber** and a small **white** highlight.

## What's Next?

This is one of those in-between pictures. Meant as a sketch, it could easily be fully rendered in coloured pencil or even paints. Watercolour, which I generally use, would not be entirely satisfactory as it would fail to capture the gloomy atmosphere. Oils would be more appropriate for the subject.

# CENTAUR

Centaurs are usually associated so intimately with classical Greece that it's rare to see interpretations that go farther afield. This mythological creature is half-human and half-animal, with the torso of a man joined at his waist to the horse's withers where its neck would be. Consorts of Bacchus, they were often pictured brawling and fighting (or abducting nymphs), and the battle of the Lapithae and the centaurs is a favourite with sculptors of antiquity.

## Project techniques

- Combining anatomy of different species
- Creating a centaur culture in a concept sketch
- Inventing armour and weapons

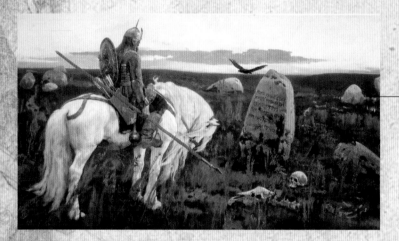

## Armour glossary

Here is a mini glossary of the centaur's armour to help you identify the elements as they appear:
- **Barding:** a defensive covering used for horses
- **Coif:** the chain mail hood worn beneath the helmet, covering neck and shoulders
- **Helmet:** armour protection for the head, and this one incorporates an ear guard
- **Nasal:** a strip of metal on the front of the helmet which protects the nose
- **Disc and splint:** light arm guard defence (protecting the outside of the upper arm in this case)
- **Vambrace:** armour covering the lower arm from the wrist to the elbow

## Ideas and inspiration

Taking a classical creature from his 'normal' environment is very much what myth-transferral is all about. Stories and myths travel, gaining in richness and complexity as they go from culture to culture. I was inspired in the development of my centaur by the winged hussars of 16th and 17th century Poland who had extraordinary styles of armour and were famous for the huge wings that they wore on their backs or attached to their horses' saddles.

## Project references

Being an immoderately enthusiastic admirer of the work of Russian painter Victor Vasnetzov (1848–1926), I thought, why not a medieval bogatyr centaur? His painting *A Knight at the Crossroads* (1882) is the starting point. In my drawing though, the Russian knight-errant has merged to become one with his steed, a centaur ready to do battle.

## Thumbnail sketch

A thumbnail sketch is useful to preview your drawing and will help you to avoid common mistakes like starting a sketch in just the wrong part of the sheet so that the image you have in mind will not fit in. Nestling in the bottom right-hand corner of my drawing, the thumbnail helps me to ensure I position the centaur to fit him all in from the tip of his wings to the end of his tail.

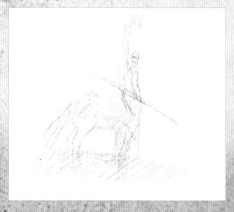

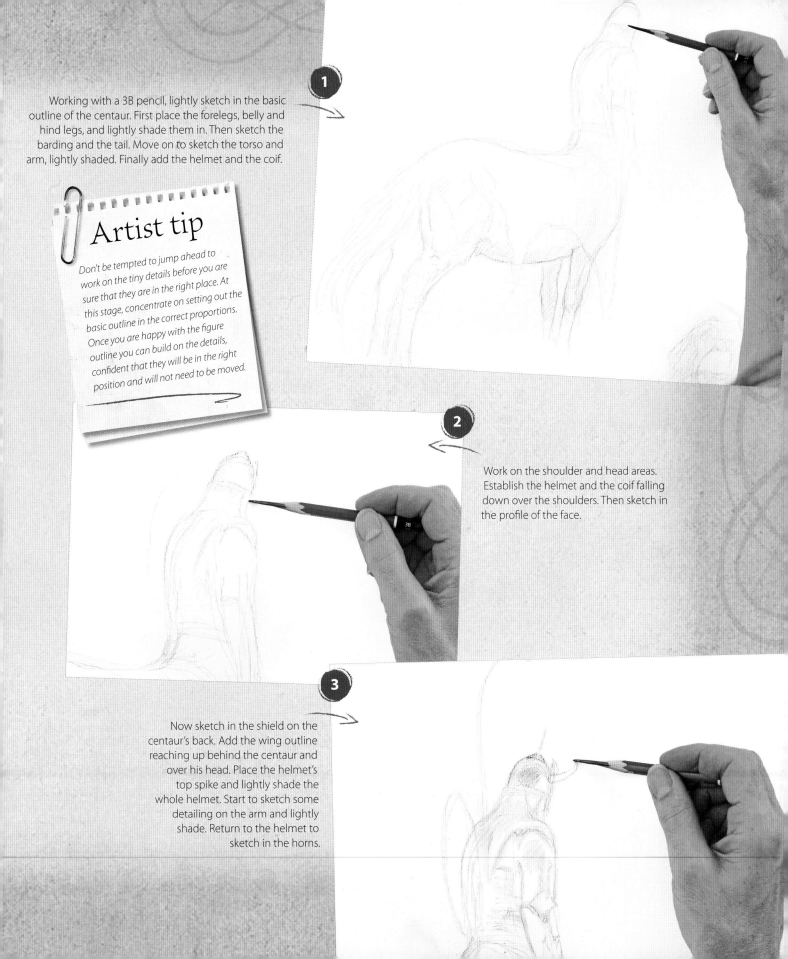

**1**

Working with a 3B pencil, lightly sketch in the basic outline of the centaur. First place the forelegs, belly and hind legs, and lightly shade them in. Then sketch the barding and the tail. Move on to sketch the torso and arm, lightly shaded. Finally add the helmet and the coif.

## Artist tip

Don't be tempted to jump ahead to work on the tiny details before you are sure that they are in the right place. At this stage, concentrate on setting out the basic outline in the correct proportions. Once you are happy with the figure outline you can build on the details, confident that they will be in the right position and will not need to be moved.

**2**

Work on the shoulder and head areas. Establish the helmet and the coif falling down over the shoulders. Then sketch in the profile of the face.

**3**

Now sketch in the shield on the centaur's back. Add the wing outline reaching up behind the centaur and over his head. Place the helmet's top spike and lightly shade the whole helmet. Start to sketch some detailing on the arm and lightly shade. Return to the helmet to sketch in the horns.

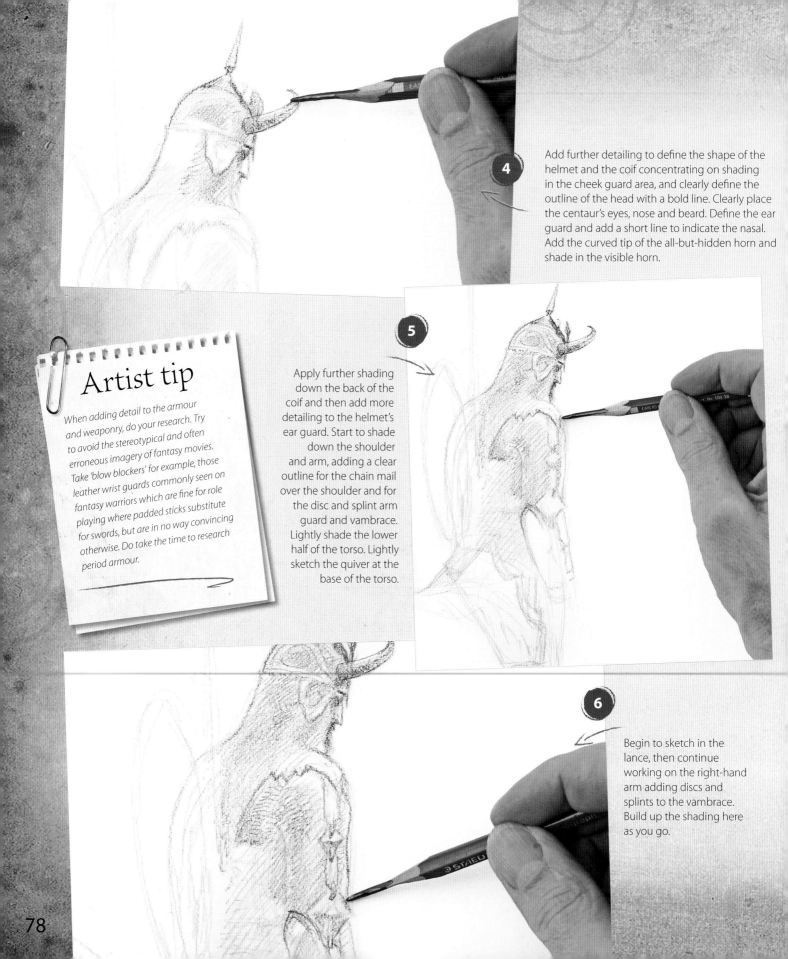

**4** Add further detailing to define the shape of the helmet and the coif concentrating on shading in the cheek guard area, and clearly define the outline of the head with a bold line. Clearly place the centaur's eyes, nose and beard. Define the ear guard and add a short line to indicate the nasal. Add the curved tip of the all-but-hidden horn and shade in the visible horn.

## Artist tip

When adding detail to the armour and weaponry, do your research. Try to avoid the stereotypical and often erroneous imagery of fantasy movies. Take 'blow blockers' for example, those leather wrist guards commonly seen on fantasy warriors which are fine for role playing where padded sticks substitute for swords, but are in no way convincing otherwise. Do take the time to research period armour.

**5** Apply further shading down the back of the coif and then add more detailing to the helmet's ear guard. Start to shade down the shoulder and arm, adding a clear outline for the chain mail over the shoulder and for the disc and splint arm guard and vambrace. Lightly shade the lower half of the torso. Lightly sketch the quiver at the base of the torso.

**6** Begin to sketch in the lance, then continue working on the right-hand arm adding discs and splints to the vambrace. Build up the shading here as you go.

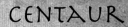

**7** Add further shadow shading to the coif and horn, and outline the ear guard. Now define the strapping across the centaur's back and clearly establish a belt.

**8** Add rivets around the centaur's helmet and use a putty eraser to pull out some highlights here. Develop the shading down the back of the neck. Then move back to the arm and add further stronger outlines and shading here.

**9** Now sketch in the dagger handle and scabbard. Establish the edge of the quiver and shade across it.

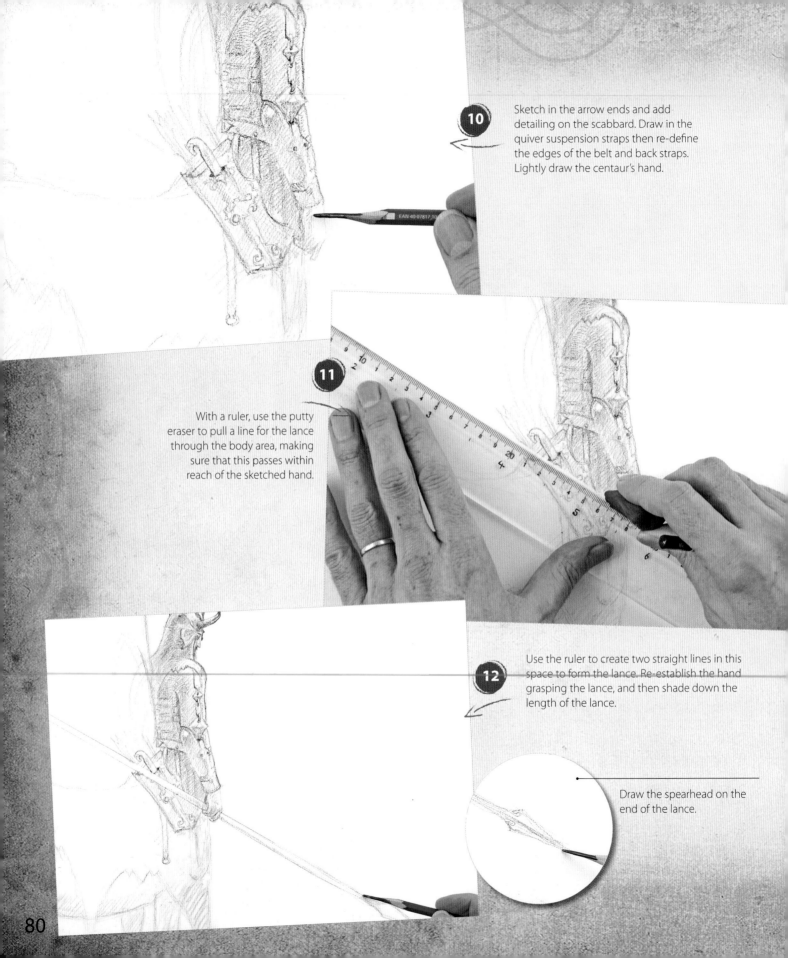

**10** Sketch in the arrow ends and add detailing on the scabbard. Draw in the quiver suspension straps then re-define the edges of the belt and back straps. Lightly draw the centaur's hand.

**11** With a ruler, use the putty eraser to pull a line for the lance through the body area, making sure that this passes within reach of the sketched hand.

**12** Use the ruler to create two straight lines in this space to form the lance. Re-establish the hand grasping the lance, and then shade down the length of the lance.

Draw the spearhead on the end of the lance.

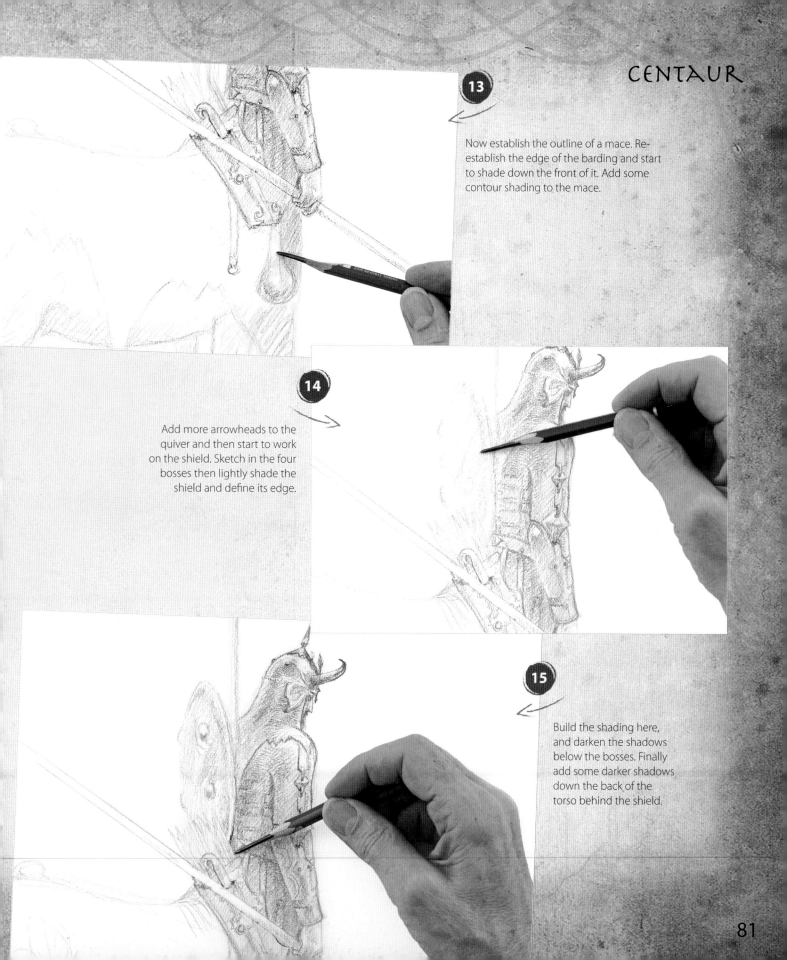

**13**

Now establish the outline of a mace. Re-establish the edge of the barding and start to shade down the front of it. Add some contour shading to the mace.

**14**

Add more arrowheads to the quiver and then start to work on the shield. Sketch in the four bosses then lightly shade the shield and define its edge.

**15**

Build the shading here, and darken the shadows below the bosses. Finally add some darker shadows down the back of the torso behind the shield.

# CENTAUR

**16**

Clearly define the outline of the wing and then start to add the plumes. Move up to the summit of the wing and draw its end detail.

**17**

Apply further shading down the right-hand foreleg and hoof, and further define the edge of the barding adding the tassel detailing.

**18**

Apply lightly sketched guidelines across the barding and then apply diamond-shaped decorations, using the guidelines to ensure equal spacing.

**19**

Outline and darkly shade in the stop to establish its volume. Shade across the barding with clean, directional hatching to give a unified tone. Shade the centaur's body working down to the hooves, defining the line of the hind legs, and filling in the shading on the left-hand foreleg. Fill out the tail with wavy lines to create depth. Add dark shadows on the diamond-shaped plates of the barding, then cross-hatch here to build the shape and volume.

**20**

Further define the edge of the barding, and then erase highlights. Add a hill shape in the background, with a lightly shaded shadow on the ground beneath the centaur.

# CENTAUR

**A** *Dagger hilt: a horse head motif seems fitting for the centaur.*

**B** *Sword hilt: the sword isn't visible in the drawing, but it's tempting to design one anyway.*

## The Final Image

Rather than develop the landscape in the background, I have used the final image to focus in on the detail of the centaur's weapons and armour with larger drawn details filling in the edges of the piece. More than a nodding acquaintance with actual period weaponry can give authenticity to your fantasy work. Try to avoid the over-complex and often incongruous weapons that so easily – and uncomfortably – creep into fantasy: big and pointy with loads of spikes is not always a good plan.

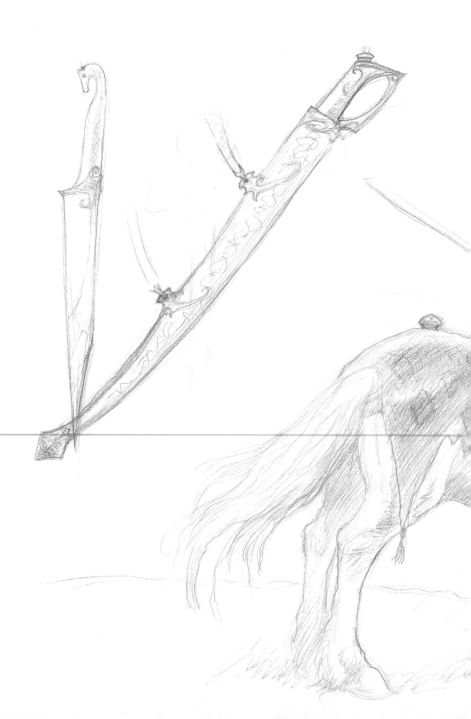

## What's Next?

This is a 'concept' sketch, providing detail and atmosphere for developing the picture into several finished colour pieces featuring the same character. Doing sketches like this is really a good way to open up a window on a world. As you define the physical practicalities of fantasy creatures, you ask more questions than you answer: what are their cities like, do they live perhaps in tents, how does a centaur army haul heavy equipment? Pursuing these in sketch form can be very enriching. (I do wish I had chosen a bigger piece of paper, though, and drawn the centaur two or three times the size in order to be able to indulge in more detailing.)

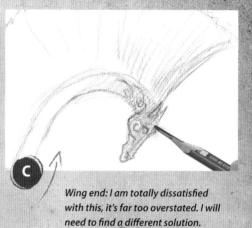

**C** *Wing end: I am totally dissatisfied with this, it's far too overstated. I will need to find a different solution.*

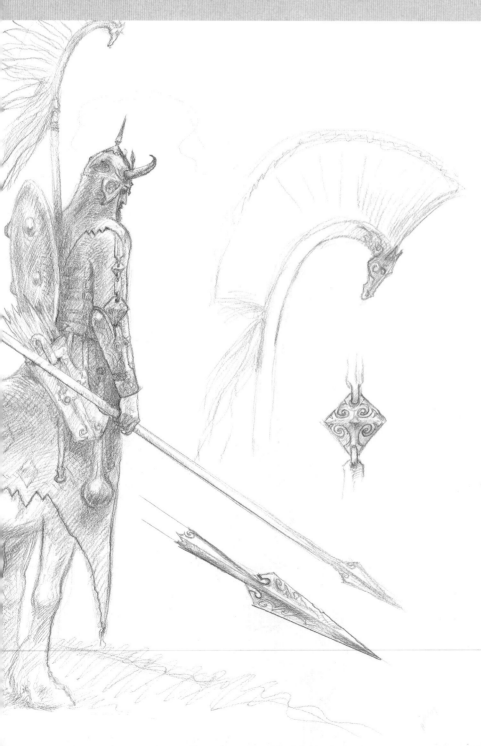

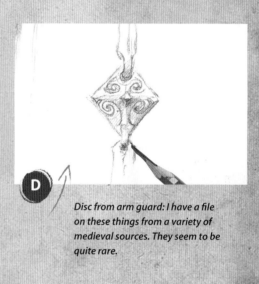

**D** *Disc from arm guard: I have a file on these things from a variety of medieval sources. They seem to be quite rare.*

**E** *Spearhead: here I am trying to find a novel design, something a little more complex than the original.*

# ORC

This is an orc, an Uruk to be exact, a fictional character from J.R.R. Tolkien's *The Two Towers*. These soldiers, renowned for their great strength, fought in the army of the great wizard Saruman the White who is said to have bred this 'black evil' from orcs and men.

### Project techniques

- Achieving symmetry
- Drawing armour with graphite only
- Exploring armour design

### Ideas and inspiration

The menacing figure of an orc warrior is a great opportunity to develop a greater understanding of armour design and how to render it in sketch form: the shiny reflective surfaces, the knitted texture of the chain mail, and the dents and blows of battle.

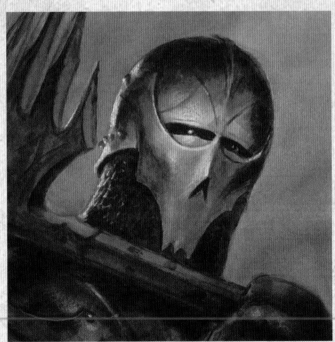

*I did a design a few years ago, one card out of many for a boardgame – a slightly frustrating exercise since the original was so small.*

### Project references

I did a design a few years ago, one card out of many for a boardgame – a slightly frustrating exercise since the original was so small. This is a chance to revisit that. I also referred to the many books on armour that I have to explore the body armour anew.

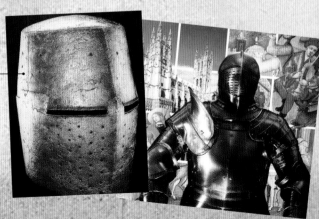

Working with a 4B pencil, first sketch the outline of the armoured orc. Lightly outline the helmet and shoulders, from the start doing your best to keep the drawing symmetrical adjusting as necessary as you go along. Add the eye slits, the rivets and the visor. Extend the neckline down into the shoulders, drawing in the plates of the pauldron. Lightly shade.

Strengthen the neckline of the breastplate and the pauldrons, then return to the helmet and strengthen its outline. Start applying shading here to build the volume, working in one direction only. The idea is to build up the basic shape before moving on to the detail.

Apply bolder shading in the neck area (this will become chain mail), and then further define the rivets on the helmet, including the details on each side of the helmet.

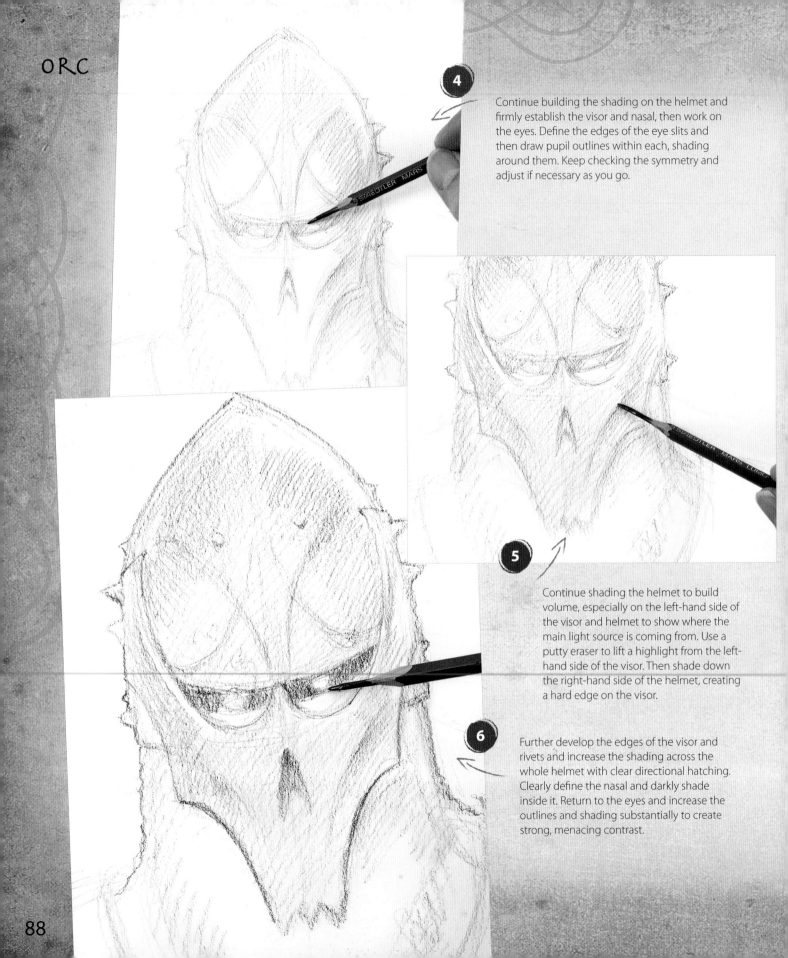

**4** Continue building the shading on the helmet and firmly establish the visor and nasal, then work on the eyes. Define the edges of the eye slits and then draw pupil outlines within each, shading around them. Keep checking the symmetry and adjust if necessary as you go.

**5** Continue shading the helmet to build volume, especially on the left-hand side of the visor and helmet to show where the main light source is coming from. Use a putty eraser to lift a highlight from the left-hand side of the visor. Then shade down the right-hand side of the helmet, creating a hard edge on the visor.

**6** Further develop the edges of the visor and rivets and increase the shading across the whole helmet with clear directional hatching. Clearly define the nasal and darkly shade inside it. Return to the eyes and increase the outlines and shading substantially to create strong, menacing contrast.

**7**

Use the putty eraser to lift highlights above the eye slits and on either side of the nasal. Apply strong cross-hatching around the neck area, then use heavy, short pencil marks to build the chain mail detail here.

## Artist tip

Putty erasers, while they can never fully efface strong pencil lines, are fantastic for lifting white areas out of a wider ground. Simply tamping the paper will lift the graphite off, especially if you are using softer pencils, and if the putty eraser is clean it will not result in smudging. So don't be afraid to be bold with your shading; you can always go back and lighten the effect.

Return to the helmet and continue to build the shading. As you work, you will need to re-define the rivets and edging as they may become lost under an increasing build up of density. Use the putty eraser to lift out decorative curves above the eye slits. Draw the 'v' shape rising from the central forehead as shown.

Shade into the corners of the helmet panels above the eye slits further. Apply strong shading down the right-hand side of the visor to imply the cheek area. Then work down the right-hand side of the helmet and neck with strong directional shading to build the volume of the chain mail.

**8**

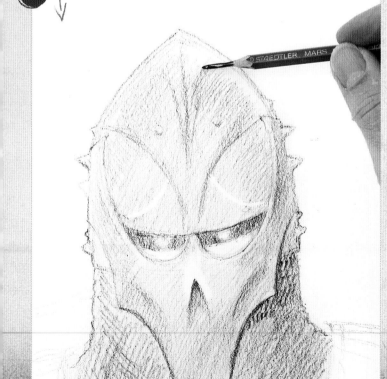

**9**

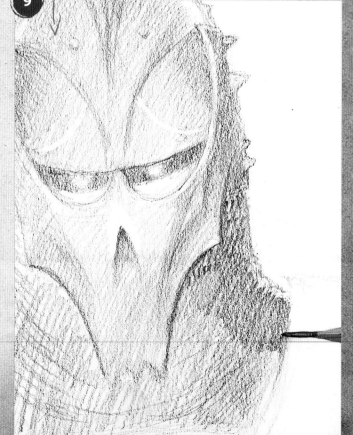

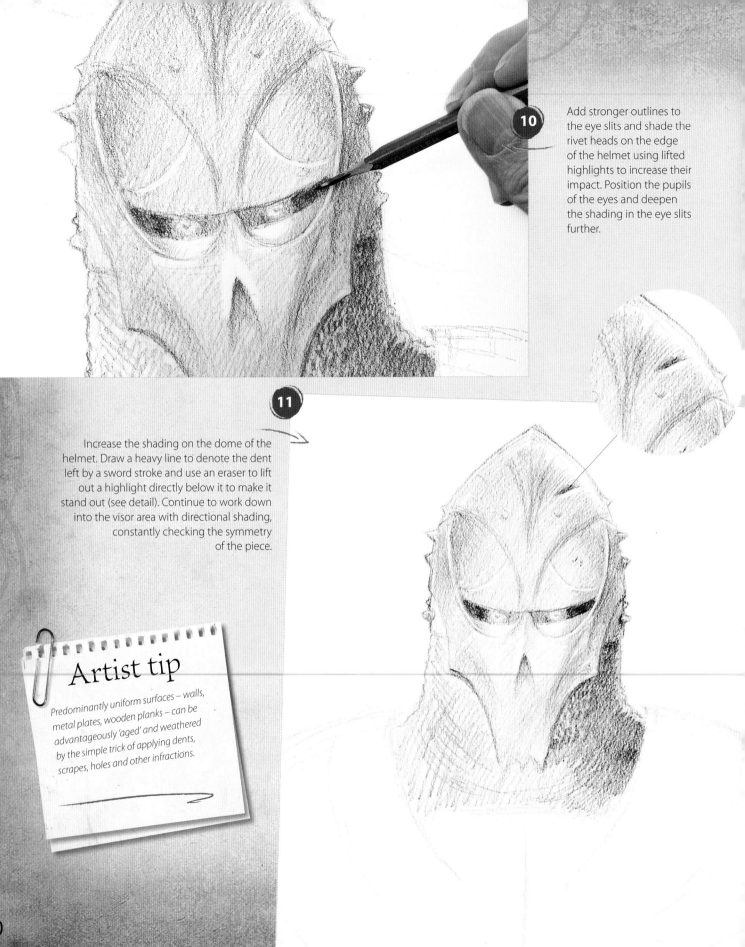

**10** Add stronger outlines to the eye slits and shade the rivet heads on the edge of the helmet using lifted highlights to increase their impact. Position the pupils of the eyes and deepen the shading in the eye slits further.

**11** Increase the shading on the dome of the helmet. Draw a heavy line to denote the dent left by a sword stroke and use an eraser to lift out a highlight directly below it to make it stand out (see detail). Continue to work down into the visor area with directional shading, constantly checking the symmetry of the piece.

## Artist tip

*Predominantly uniform surfaces – walls, metal plates, wooden planks – can be advantageously 'aged' and weathered by the simple trick of applying dents, scrapes, holes and other infractions.*

Reinforce the bottom edge of the visor. Develop further texture on the helmet by gently lifting further highlights. Use your pencil to apply short, strong marks to build up the impression of denting on either side.

**12**

Start filling out more detail on the chest. Further establish the edge of the pauldron and the plating on the right-hand shoulder. Lightly shade the chest area and then build the chain mail on the neck with heavy cross-hatching.

**13**

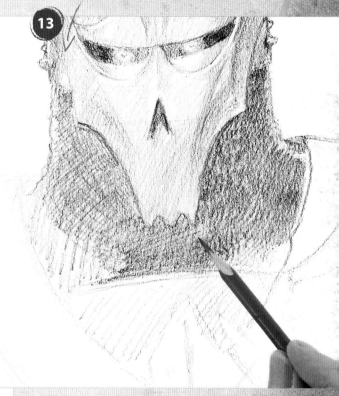

Add further definition to the edge of the visor and the plating across the right-hand shoulder. Develop the left-hand side of the visor by shading to match the right-hand side. Add a dent to the nasal (see step 11). Return to the pauldron and continue to shape the plating contours on both shoulders lightly working down through both arms to the waist. Begin to sketch in the outline of what will become the raised neck guard on the left-hand shoulder.

**14**

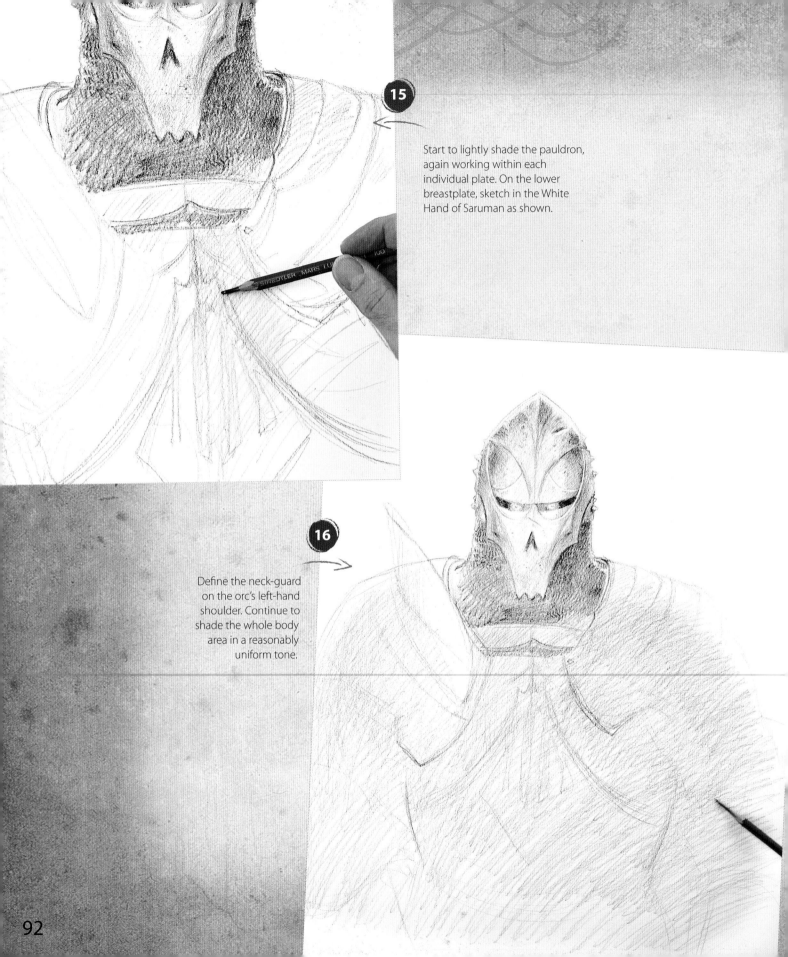

**15** Start to lightly shade the pauldron, again working within each individual plate. On the lower breastplate, sketch in the White Hand of Saruman as shown.

**16** Define the neck-guard on the orc's left-hand shoulder. Continue to shade the whole body area in a reasonably uniform tone.

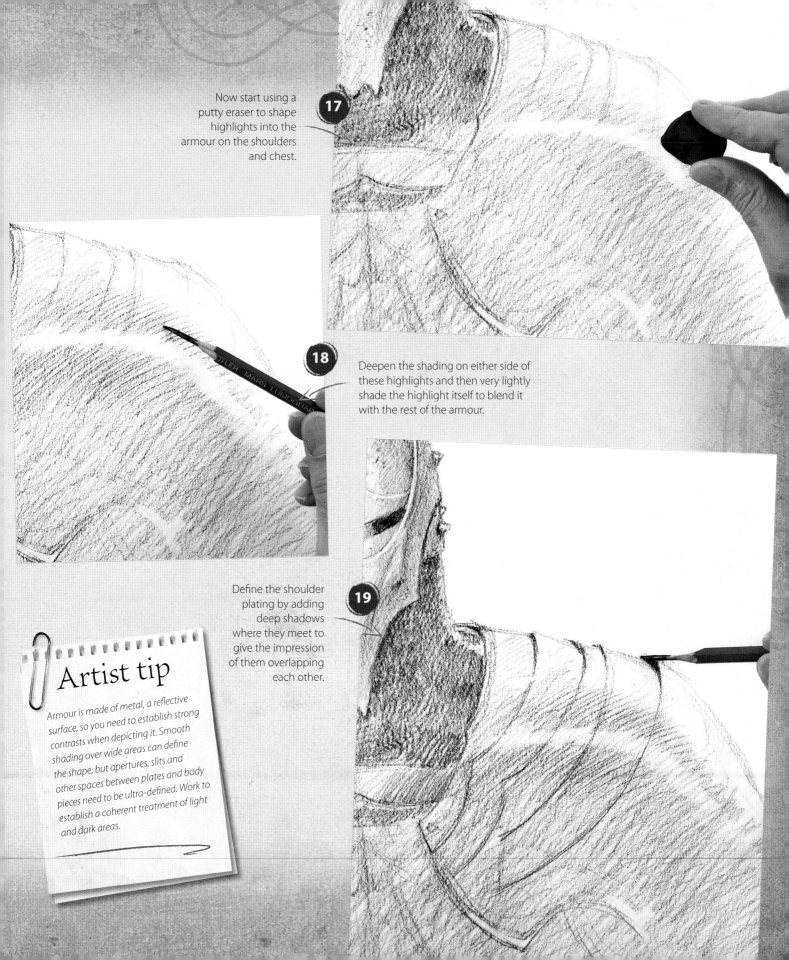

**17** Now start using a putty eraser to shape highlights into the armour on the shoulders and chest.

**18** Deepen the shading on either side of these highlights and then very lightly shade the highlight itself to blend it with the rest of the armour.

**19** Define the shoulder plating by adding deep shadows where they meet to give the impression of them overlapping each other.

## Artist tip

Armour is made of metal, a reflective surface, so you need to establish strong contrasts when depicting it. Smooth shading over wide areas can define the shape, but apertures, slits and other spaces between plates and body pieces need to be ultra-defined. Work to establish a coherent treatment of light and dark areas.

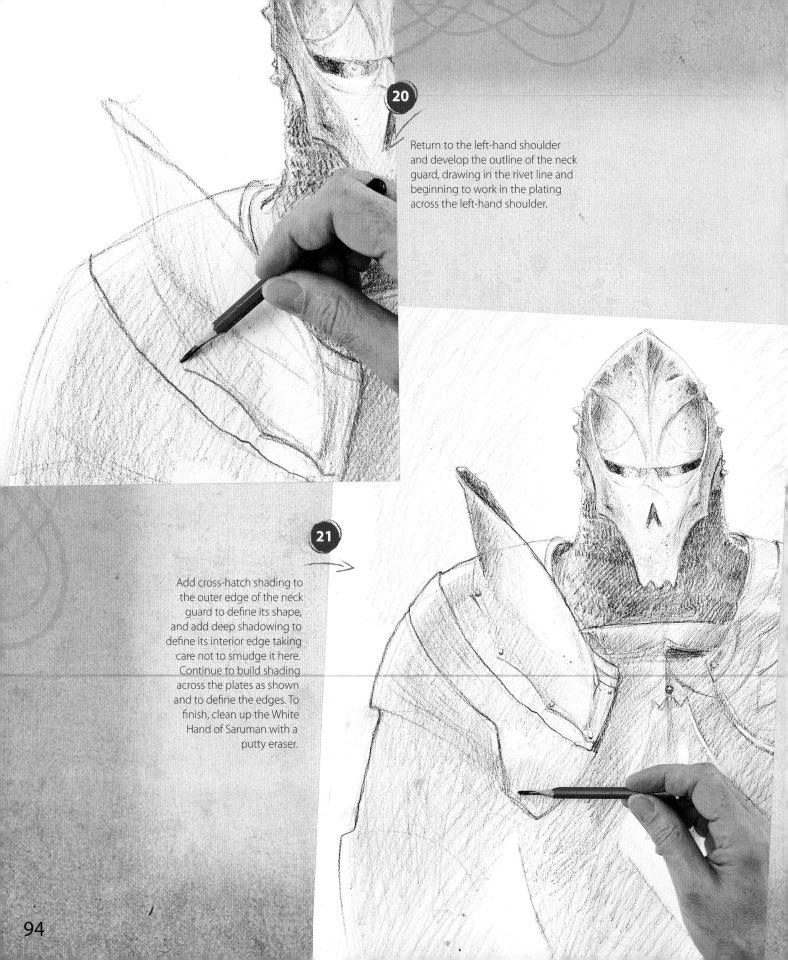

**20**

Return to the left-hand shoulder and develop the outline of the neck guard, drawing in the rivet line and beginning to work in the plating across the left-hand shoulder.

**21**

Add cross-hatch shading to the outer edge of the neck guard to define its shape, and add deep shadowing to define its interior edge taking care not to smudge it here. Continue to build shading across the plates as shown and to define the edges. To finish, clean up the White Hand of Saruman with a putty eraser.

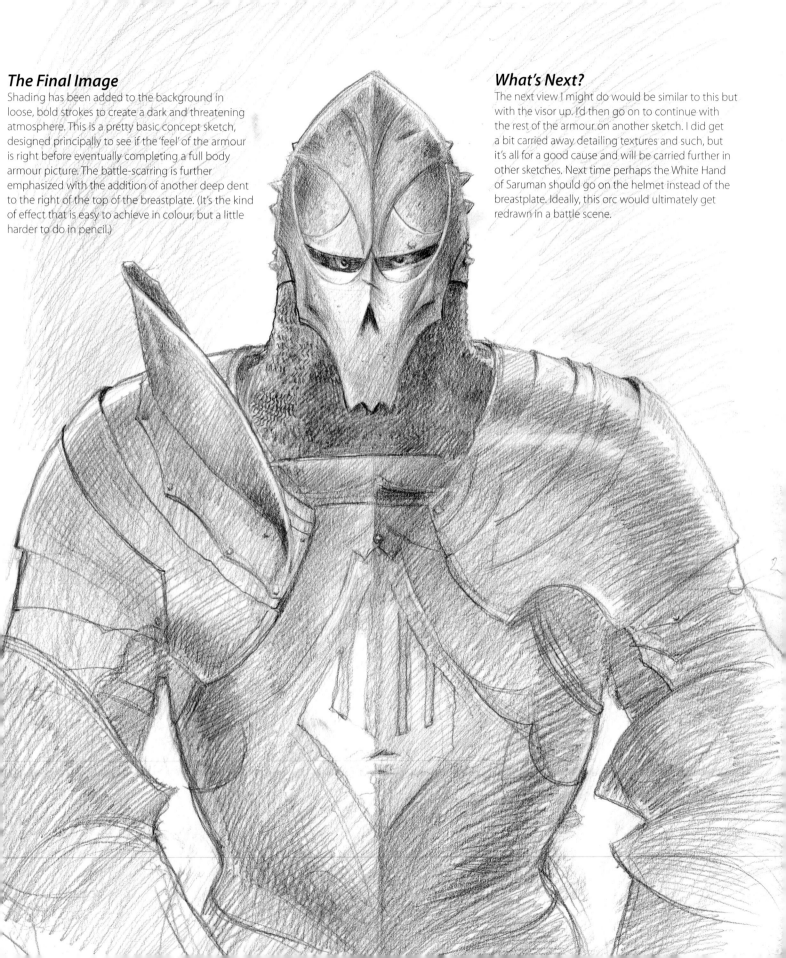

## The Final Image
Shading has been added to the background in loose, bold strokes to create a dark and threatening atmosphere. This is a pretty basic concept sketch, designed principally to see if the 'feel' of the armour is right before eventually completing a full body armour picture. The battle-scarring is further emphasized with the addition of another deep dent to the right of the top of the breastplate. (It's the kind of effect that is easy to achieve in colour, but a little harder to do in pencil.)

## What's Next?
The next view I might do would be similar to this but with the visor up. I'd then go on to continue with the rest of the armour on another sketch. I did get a bit carried away detailing textures and such, but it's all for a good cause and will be carried further in other sketches. Next time perhaps the White Hand of Saruman should go on the helmet instead of the breastplate. Ideally, this orc would ultimately get redrawn in a battle scene.

# ARWEN

Arwen is a dark-haired elven beauty and daughter of the Lord Elrond of Rivendell. Caught between two worlds, she is one of Tolkien's more tragic feminine characters. Her love for Aragorn, a mortal man, forever sunders her from her people and from her immortality.

## Project techniques

- Characters in situation
- Implying a back story without action

## Project references

The Arwen gave me the perfect excuse to gather together all the pictures of beautiful actresses and models that I have collected from magazines over the years to provide me with inspiration for my work. However, my Arwen has a look all of her own.

## Ideas and inspiration

Critics often dismiss Tolkien's female characters as inconsequential, which is a grand shame. They simply require more attentive reading. The object of this sketch is to try to capture Arwen's beauty and to hint at her sense of loss.

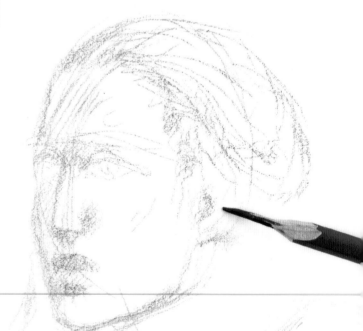

Starting with a 3B pencil, sketch Arwen's shoulders and neck. Lightly sketch in her head, profile and jaw line. Work in her eyebrows and then draw her nose and mouth so that her cheeks and chin begin to take shape. Now work on the outline of her hair and start to lightly shade this, and begin to suggest the shape of the ear.

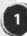

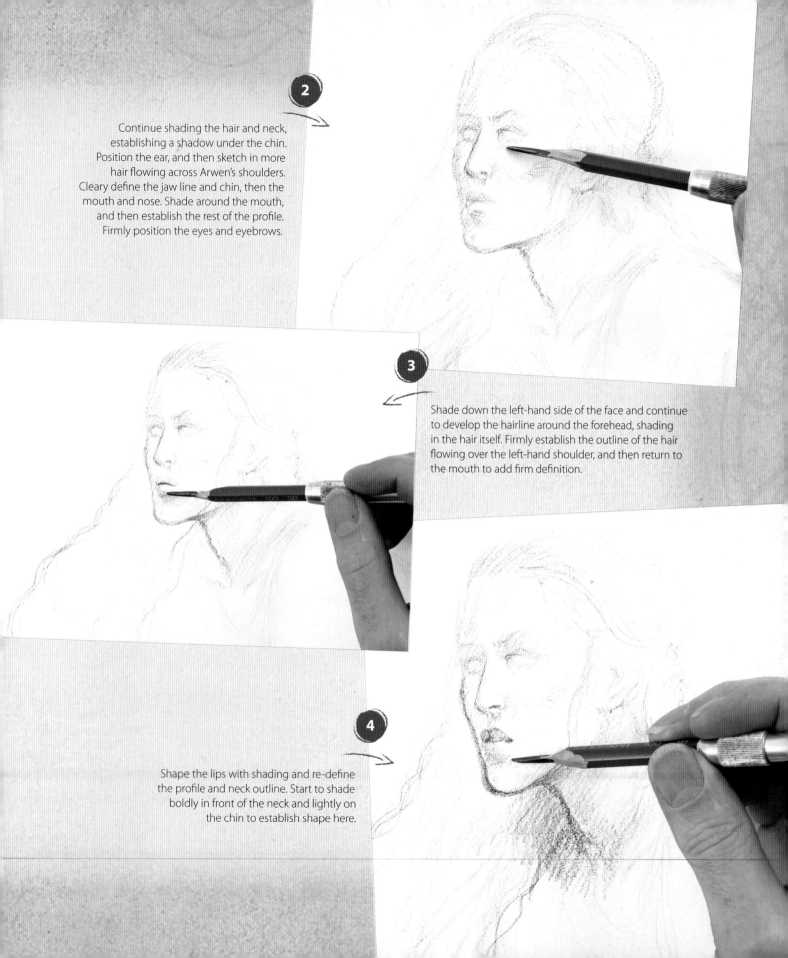

**2**

Continue shading the hair and neck, establishing a shadow under the chin. Position the ear, and then sketch in more hair flowing across Arwen's shoulders. Cleary define the jaw line and chin, then the mouth and nose. Shade around the mouth, and then establish the rest of the profile. Firmly position the eyes and eyebrows.

**3**

Shade down the left-hand side of the face and continue to develop the hairline around the forehead, shading in the hair itself. Firmly establish the outline of the hair flowing over the left-hand shoulder, and then return to the mouth to add firm definition.

**4**

Shape the lips with shading and re-define the profile and neck outline. Start to shade boldly in front of the neck and lightly on the chin to establish shape here.

# ARWEN

Continue to develop the facial features. Block in the mouth and then define the upper eyelids, shading above them. Shade around the face to build the contours, particularly on the cheekbones and forehead.

**5**

**6**

Working on the hair, build the shape of the hairline and the back of the head – lightly shade. Then start to cross-hatch on this to quickly develop volume and texture. Define the ear with a clear outline.

**7**

Now work on the body. Increase the shading around the base of the neck, and then sketch the right-hand shoulder and down into the arm, and suggest the curve of the elbow that will be resting on a balcony. Sketch the neckline of Arwen's dress and her bust line, and lightly shade through. Then start to sketch the left-hand arm and lightly shade as shown.

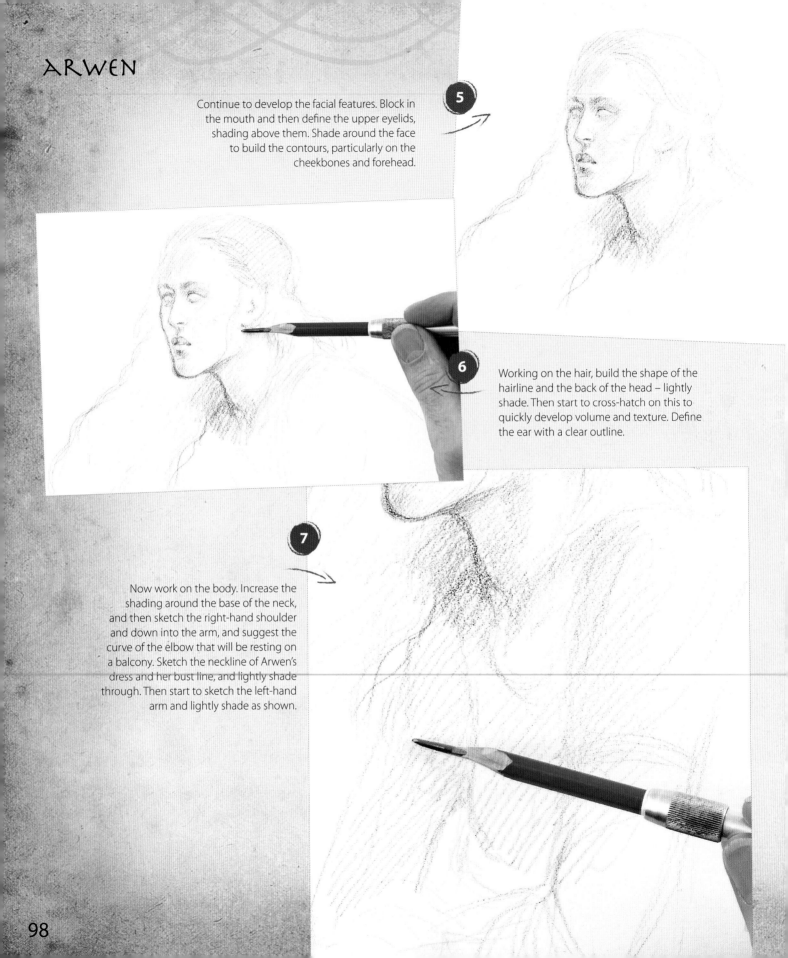

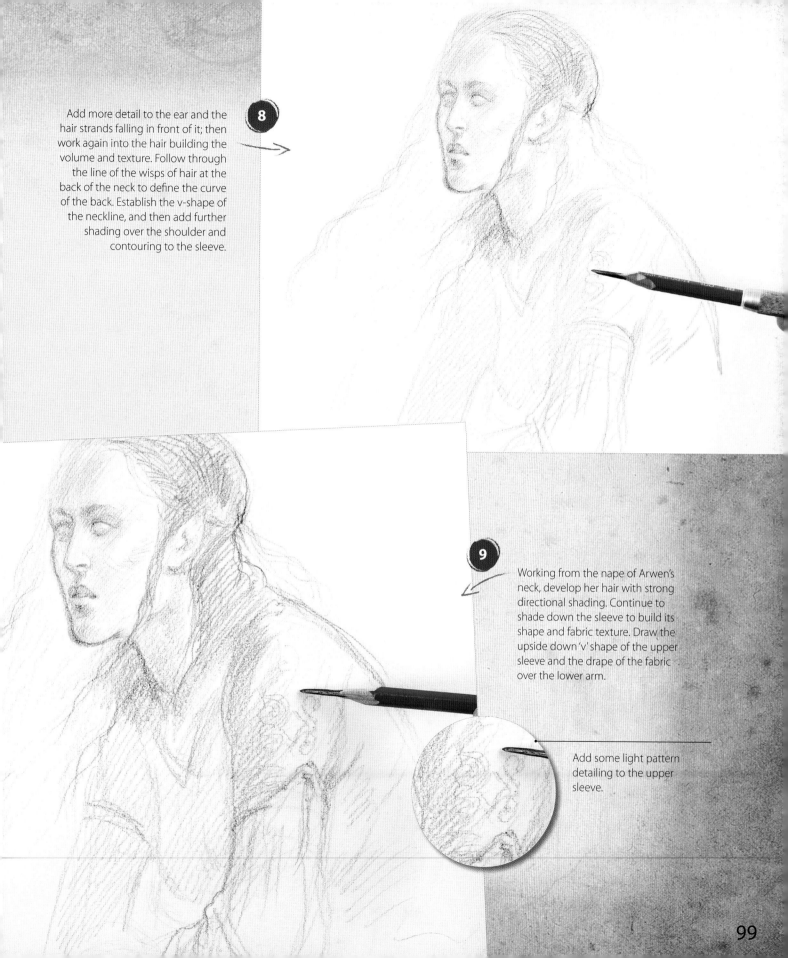

Add more detail to the ear and the hair strands falling in front of it; then work again into the hair building the volume and texture. Follow through the line of the wisps of hair at the back of the neck to define the curve of the back. Establish the v-shape of the neckline, and then add further shading over the shoulder and contouring to the sleeve.

**8**

**9**

Working from the nape of Arwen's neck, develop her hair with strong directional shading. Continue to shade down the sleeve to build its shape and fabric texture. Draw the upside down 'v' shape of the upper sleeve and the drape of the fabric over the lower arm.

Add some light pattern detailing to the upper sleeve.

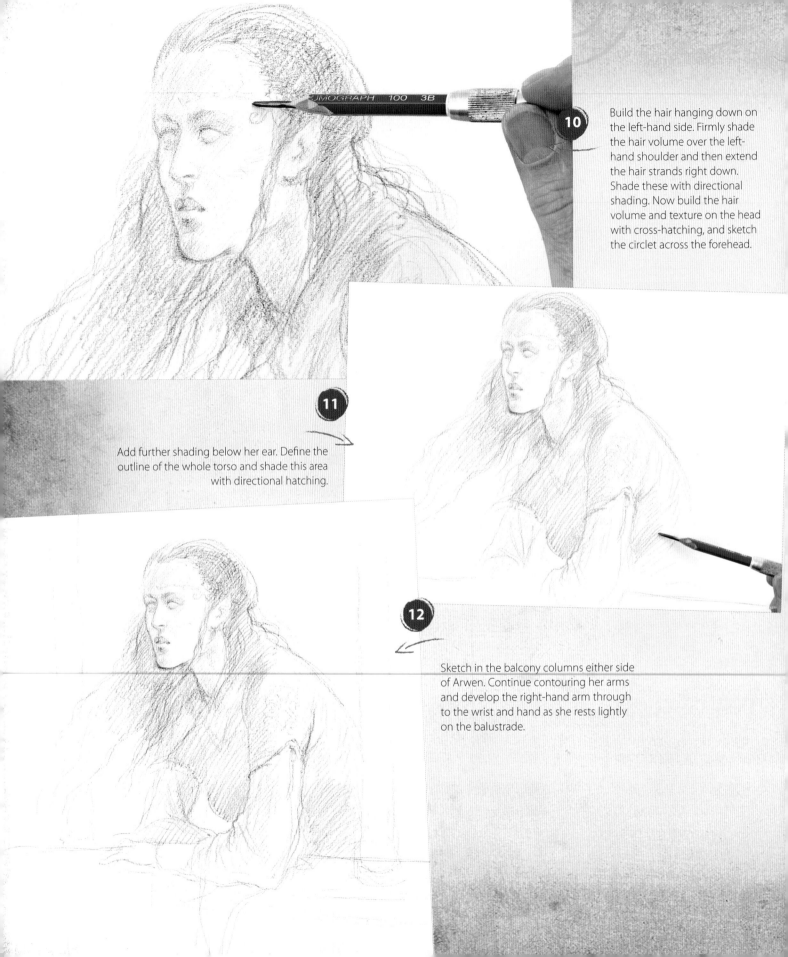

**10** Build the hair hanging down on the left-hand side. Firmly shade the hair volume over the left-hand shoulder and then extend the hair strands right down. Shade these with directional shading. Now build the hair volume and texture on the head with cross-hatching, and sketch the circlet across the forehead.

**11** Add further shading below her ear. Define the outline of the whole torso and shade this area with directional hatching.

**12** Sketch in the balcony columns either side of Arwen. Continue contouring her arms and develop the right-hand arm through to the wrist and hand as she rests lightly on the balustrade.

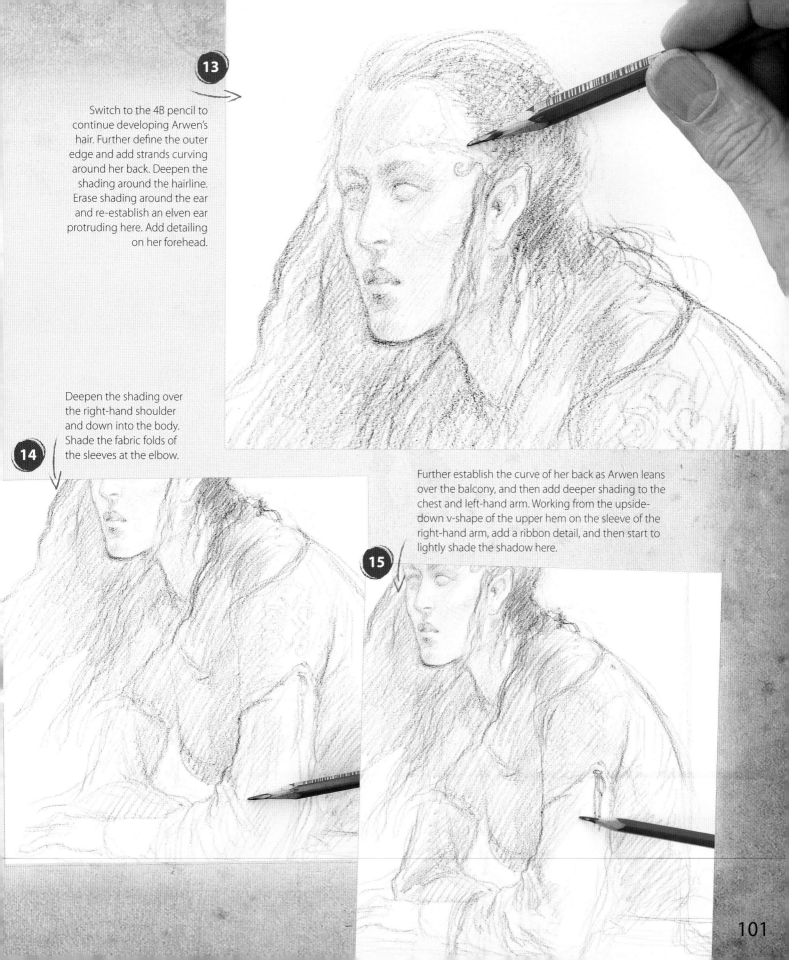

**13**

Switch to the 4B pencil to continue developing Arwen's hair. Further define the outer edge and add strands curving around her back. Deepen the shading around the hairline. Erase shading around the ear and re-establish an elven ear protruding here. Add detailing on her forehead.

Deepen the shading over the right-hand shoulder and down into the body. Shade the fabric folds of the sleeves at the elbow.

**14**

Further establish the curve of her back as Arwen leans over the balcony, and then add deeper shading to the chest and left-hand arm. Working from the upside-down v-shape of the upper hem on the sleeve of the right-hand arm, add a ribbon detail, and then start to lightly shade the shadow here.

**15**

# ARWEN

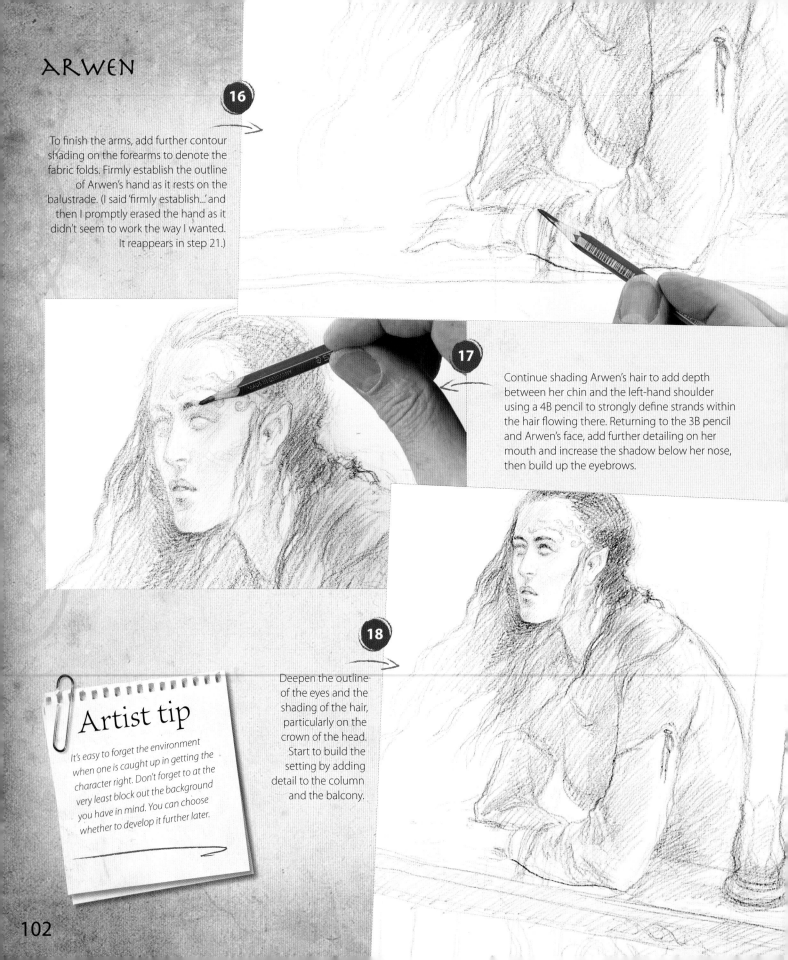

**16**

To finish the arms, add further contour shading on the forearms to denote the fabric folds. Firmly establish the outline of Arwen's hand as it rests on the balustrade. (I said 'firmly establish...' and then I promptly erased the hand as it didn't seem to work the way I wanted. It reappears in step 21.)

**17**

Continue shading Arwen's hair to add depth between her chin and the left-hand shoulder using a 4B pencil to strongly define strands within the hair flowing there. Returning to the 3B pencil and Arwen's face, add further detailing on her mouth and increase the shadow below her nose, then build up the eyebrows.

**18**

Deepen the outline of the eyes and the shading of the hair, particularly on the crown of the head. Start to build the setting by adding detail to the column and the balcony.

## Artist tip

It's easy to forget the environment when one is caught up in getting the character right. Don't forget to at the very least block out the background you have in mind. You can choose whether to develop it further later.

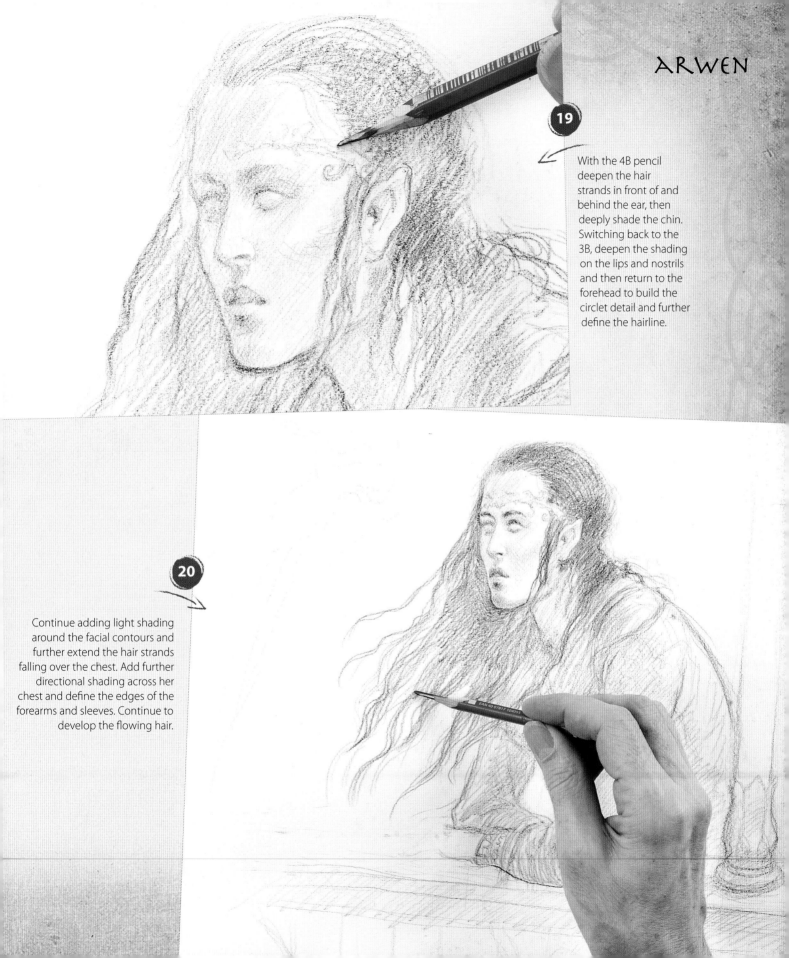

**19**

With the 4B pencil deepen the hair strands in front of and behind the ear, then deeply shade the chin. Switching back to the 3B, deepen the shading on the lips and nostrils and then return to the forehead to build the circlet detail and further define the hairline.

**20**

Continue adding light shading around the facial contours and further extend the hair strands falling over the chest. Add further directional shading across her chest and define the edges of the forearms and sleeves. Continue to develop the flowing hair.

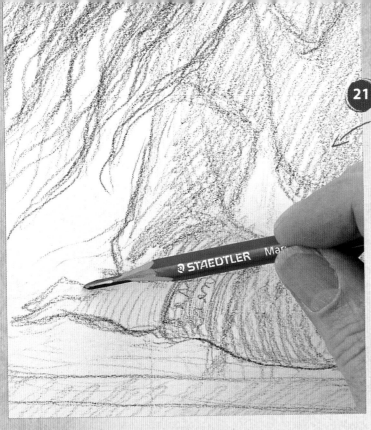

**21**

Outline the shape of the hand and define the fingers. Shade beneath the hand and along the length of the forearm.

### The Final Image

As a prelude to a colour painting, Arwen is completely overworked. Normally the drawing would never go so far but, since it did, I got a bit carried away and started working out the setting – chair back, balcony railing and columns, as well as a suggestion of the farther buildings and the valley. This sketch would represent the right half of the painting, with the valley opening into the distance and a full view of Rivendell from Arwen's balcony.

Build the backdrop. I have provided some pointers for this in the caption to the final image, but as this is a book on drawing characters we return here to complete Arwen's face. Re-define her eyelids and then add the pupils. Refine the shading around her eyes and the shape of her mouth. As you can see opposite, at the very last minute I redrew the curve of her back, making it slightly straighter.

**22**

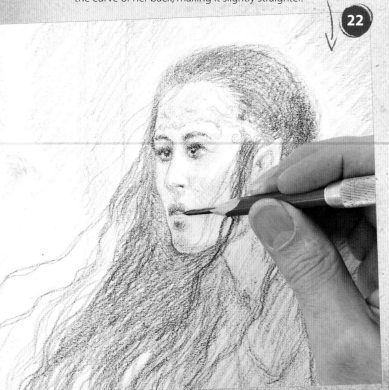

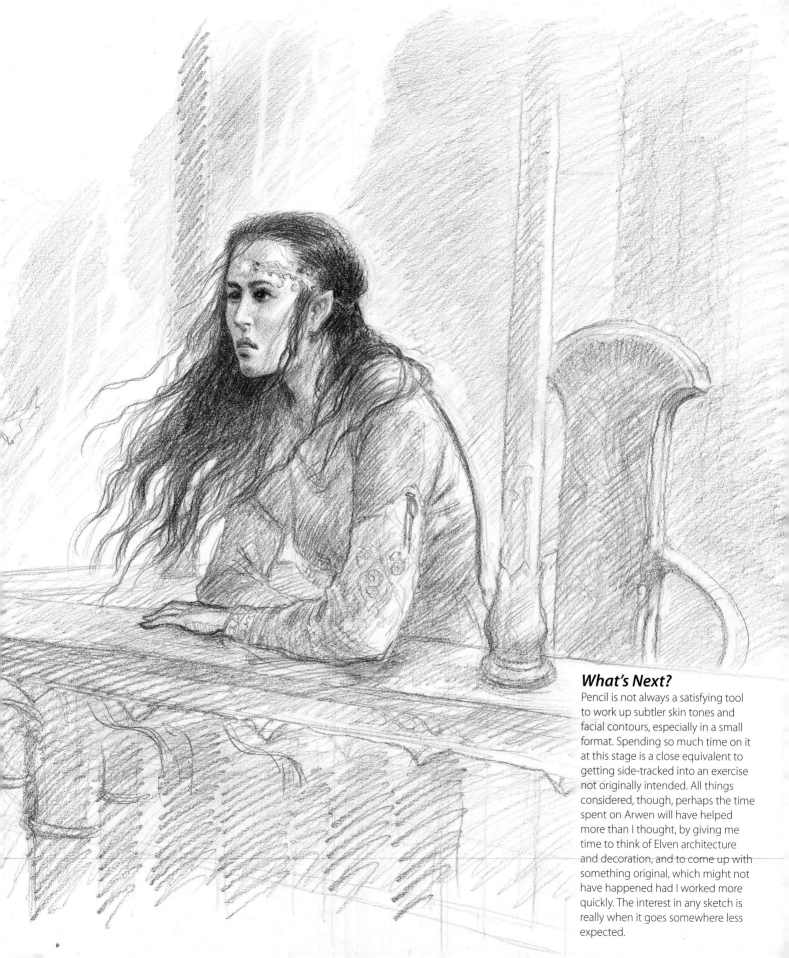

## What's Next?

Pencil is not always a satisfying tool to work up subtler skin tones and facial contours, especially in a small format. Spending so much time on it at this stage is a close equivalent to getting side-tracked into an exercise not originally intended. All things considered, though, perhaps the time spent on Arwen will have helped more than I thought, by giving me time to think of Elven architecture and decoration, and to come up with something original, which might not have happened had I worked more quickly. The interest in any sketch is really when it goes somewhere less expected.

# BALROG

The balrog in the Mines of Moria is never fully described by J.R.R. Tolkien, so one can be quite free to do one's own interpretation. My balrog is fearfully strong and menacing, shrouded in fire, darkness and shadow, and clutching the long sword it often armed itself with. It should not surprise that this fierce and fiery demon is said to rival the dragon in its capacity for destruction.

## Project techniques

- Shading and smudging
- Drawing by erasing

## Ideas and inspiration

There is huge debate amongst Tolkien fans as to whether the balrog has wings or not. In this case I've decided not to decide, and the drawing has merely a suggestion of them. The balrog is a creature of smoke and flame, both being rather unsatisfying elements to render in a black and white drawing. It is, however, a good excuse to fully indulge in a lot of serious smudging.

Taking a 4B pencil, lightly draw the outline of the body and the arm. Then work on the basic head shape by drawing the jaw line, the horns and the eyes.

## Project references

One is one's own best model (or at the very least, the most readily available), so I end up standing in for creatures as varied as Gollum and balrogs. The photo of my arm provides enough detail to serve as a guide.

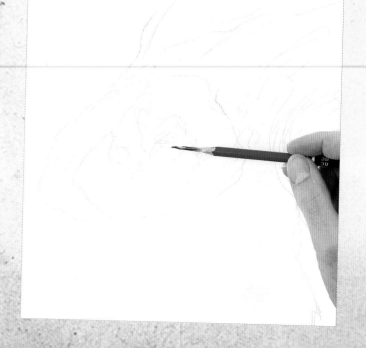

**2**

Continue to sketch the shape of the arm and the base of the wings where they attach to the shoulders. Add some initial shading, and then build the mouth by lightly sketching in some teeth.

**3**

Add a second pair of horns and then shade across the head into these. Build the face by placing the nose and further establishing the mouth and jaw. Start to establish the eyes. Keep your pencil lines light so that changes can still be made.

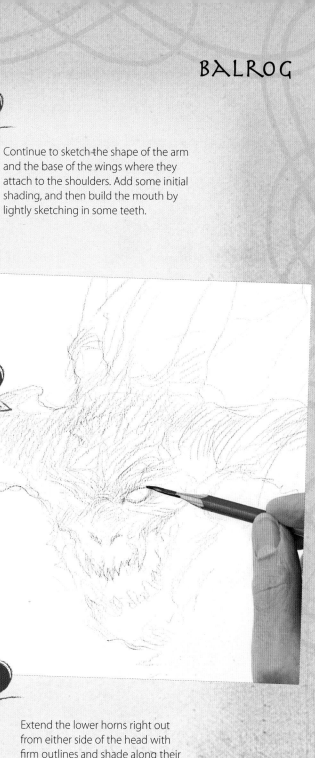

**4**

Extend the lower horns right out from either side of the head with firm outlines and shade along their full length.

# BALROG

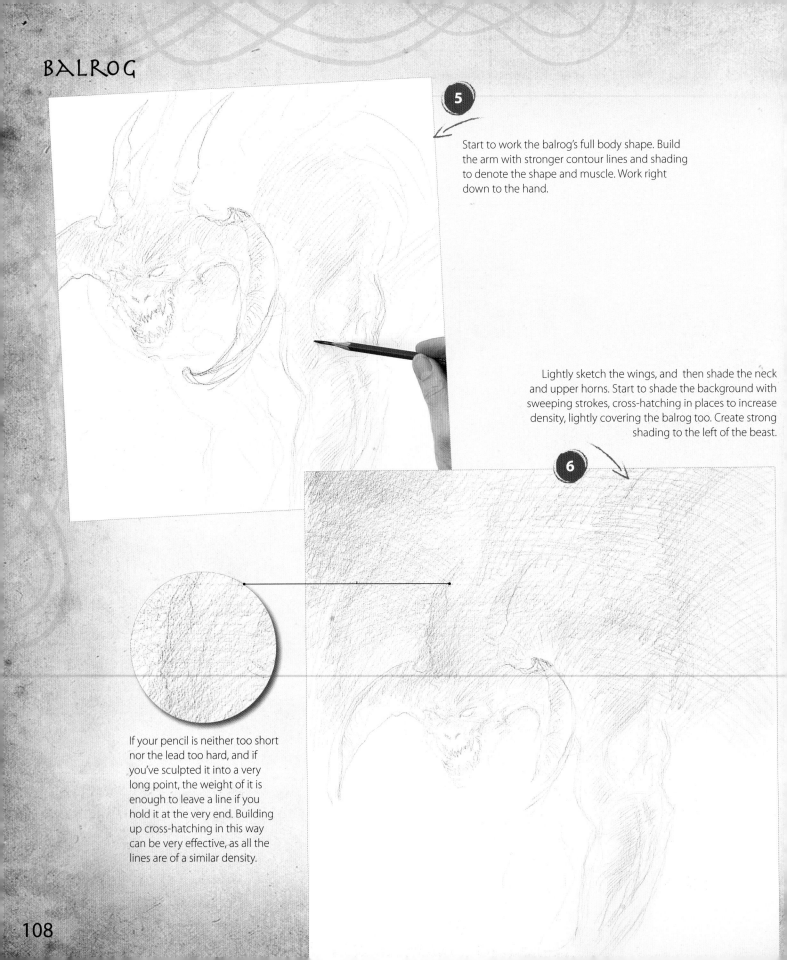

Start to work the balrog's full body shape. Build the arm with stronger contour lines and shading to denote the shape and muscle. Work right down to the hand.

Lightly sketch the wings, and  then shade the neck and upper horns. Start to shade the background with sweeping strokes, cross-hatching in places to increase density, lightly covering the balrog too. Create strong shading to the left of the beast.

6

If your pencil is neither too short nor the lead too hard, and if you've sculpted it into a very long point, the weight of it is enough to leave a line if you hold it at the very end. Building up cross-hatching in this way can be very effective, as all the lines are of a similar density.

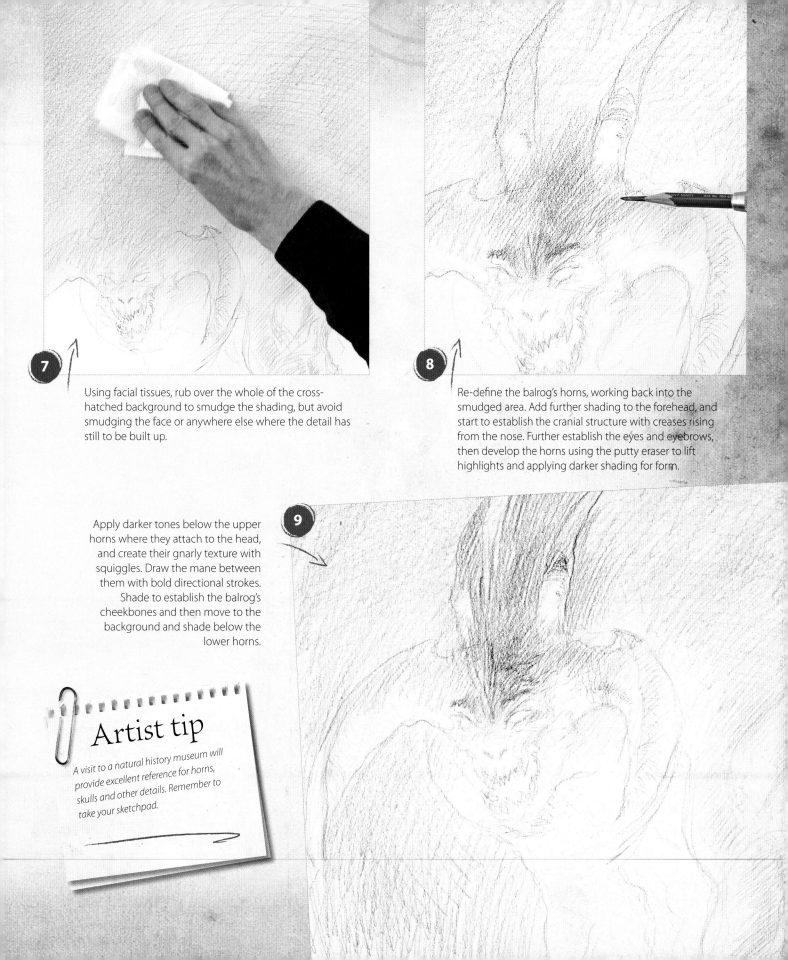

**7** Using facial tissues, rub over the whole of the cross-hatched background to smudge the shading, but avoid smudging the face or anywhere else where the detail has still to be built up.

**8** Re-define the balrog's horns, working back into the smudged area. Add further shading to the forehead, and start to establish the cranial structure with creases rising from the nose. Further establish the eyes and eyebrows, then develop the horns using the putty eraser to lift highlights and applying darker shading for form.

**9** Apply darker tones below the upper horns where they attach to the head, and create their gnarly texture with squiggles. Draw the mane between them with bold directional strokes. Shade to establish the balrog's cheekbones and then move to the background and shade below the lower horns.

## Artist tip

A visit to a natural history museum will provide excellent reference for horns, skulls and other details. Remember to take your sketchpad.

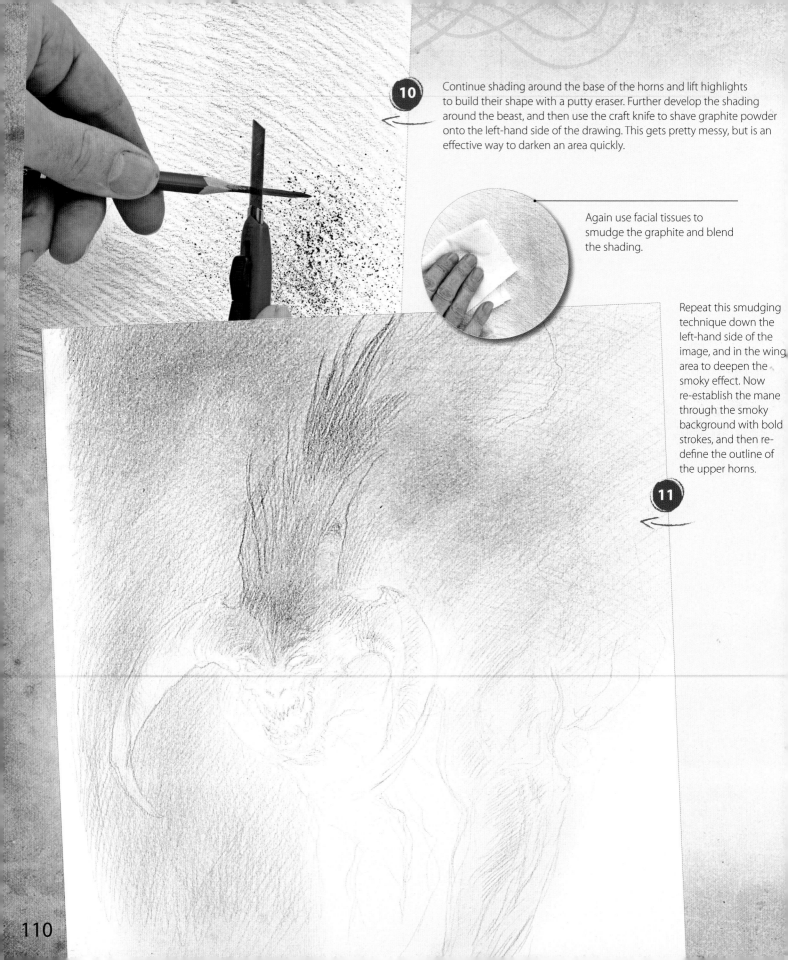

**10** Continue shading around the base of the horns and lift highlights to build their shape with a putty eraser. Further develop the shading around the beast, and then use the craft knife to shave graphite powder onto the left-hand side of the drawing. This gets pretty messy, but is an effective way to darken an area quickly.

Again use facial tissues to smudge the graphite and blend the shading.

Repeat this smudging technique down the left-hand side of the image, and in the wing area to deepen the smoky effect. Now re-establish the mane through the smoky background with bold strokes, and then re-define the outline of the upper horns.

**11**

**12** Lightly shade the neck and then return to the face, switching to a 3B pencil which will allow a little finer lines. Shade down the nose and place the nostrils. Then shade below the nose and around the cheekbones. Use heavy marks to denote the ridges on the nose.

Cross-hatch around the eyes to create form and wrinkles. Continue shading the neck and define the outline of the just-visible left-hand shoulder. With the putty eraser lift a highlight from the right-hand cheek.

**13**

**14** Continue building the shading around the forehead. Develop the left-hand lower horn by re-defining its outline and establishing its ridge with heavy shading. At this stage the rest of the horn is left white; detailing can come later.

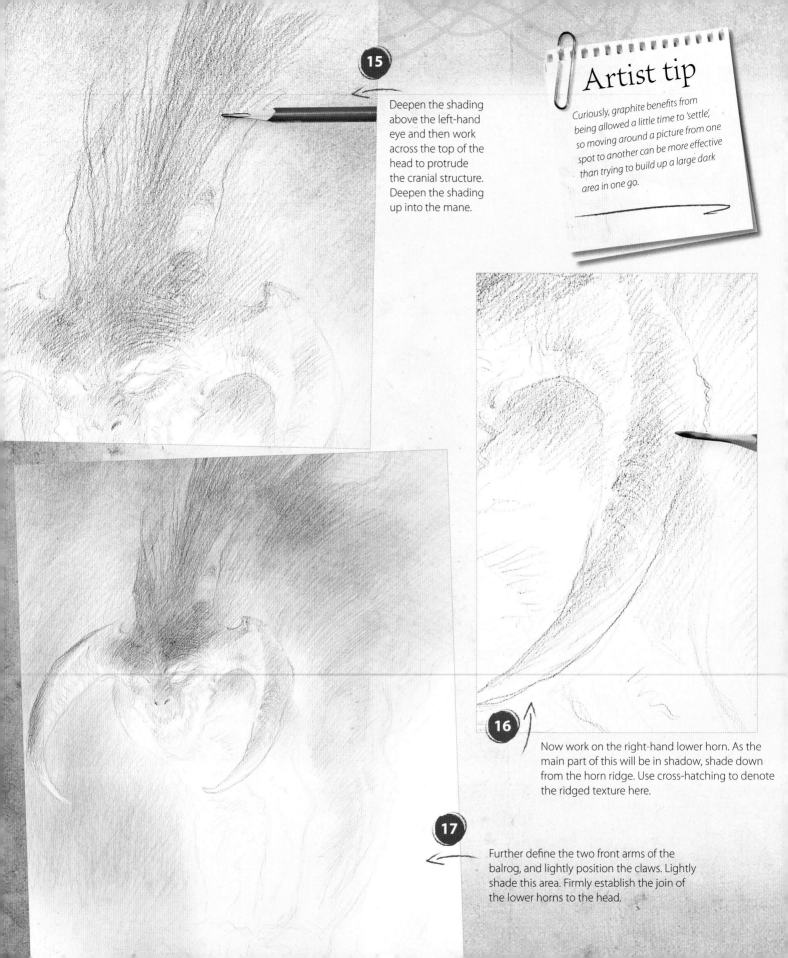

**15**

Deepen the shading above the left-hand eye and then work across the top of the head to protrude the cranial structure. Deepen the shading up into the mane.

## Artist tip

Curiously, graphite benefits from being allowed a little time to 'settle', so moving around a picture from one spot to another can be more effective than trying to build up a large dark area in one go.

**16**

Now work on the right-hand lower horn. As the main part of this will be in shadow, shade down from the horn ridge. Use cross-hatching to denote the ridged texture here.

**17**

Further define the two front arms of the balrog, and lightly position the claws. Lightly shade this area. Firmly establish the join of the lower horns to the head.

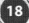

**18** Begin to define the balrog's strong neck, working down into the right-hand shoulder with contour shading. Now smudge with the facial tissues to define where the top of the arms join the chest. Some detail will be lost, but you can easily work it back up again.

**19** Shade in the area below the lower left horn and smudge as before. Use a putty eraser to define the highlight on the left arm.

**20** Move to the right-hand arm. Outline with a firm line and build the contour shading, strongly denoting the muscles as you go using the reference photo on page 106 to help you. Then use the putty eraser to pick out highlights and shape from the shading.

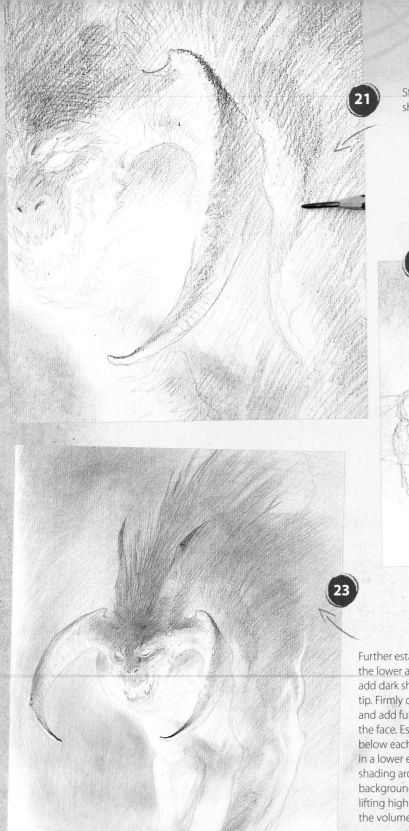

**21** Strongly increase the shading above the shoulder with bold directional strokes.

Increase the shading on both arms and then sketch in the claws clutching what will be a sword. Block in both hands with bold shading, using an eraser to lift highlights at the wrists.

**22**

**23** Further establish the edges of the lower and upper horns, and add dark shaded details to each tip. Firmly define the teeth and add further texturing to the face. Establish a highlight below each eye by drawing in a lower eyelid. Finalize the shading around the body and background, smudging and lifting highlights to enhance the volume and shape.

### The Final Image

Draw in the sword the balrog wields, and use the putty eraser to highlight its lower edge. Use the eraser also to pull out 'flames' above the sword handle. With the 4B pencil, define the upper eyelids and add the pupils. In the final image the balrog emerges from the flames and smoke, with just a suggestion of his body in the background. The smoky shading curving up to the left and right corners of the picture suggest undefined wings and the crested mane between gives an impression of the bulk of a fantastical, evil and powerful creature.

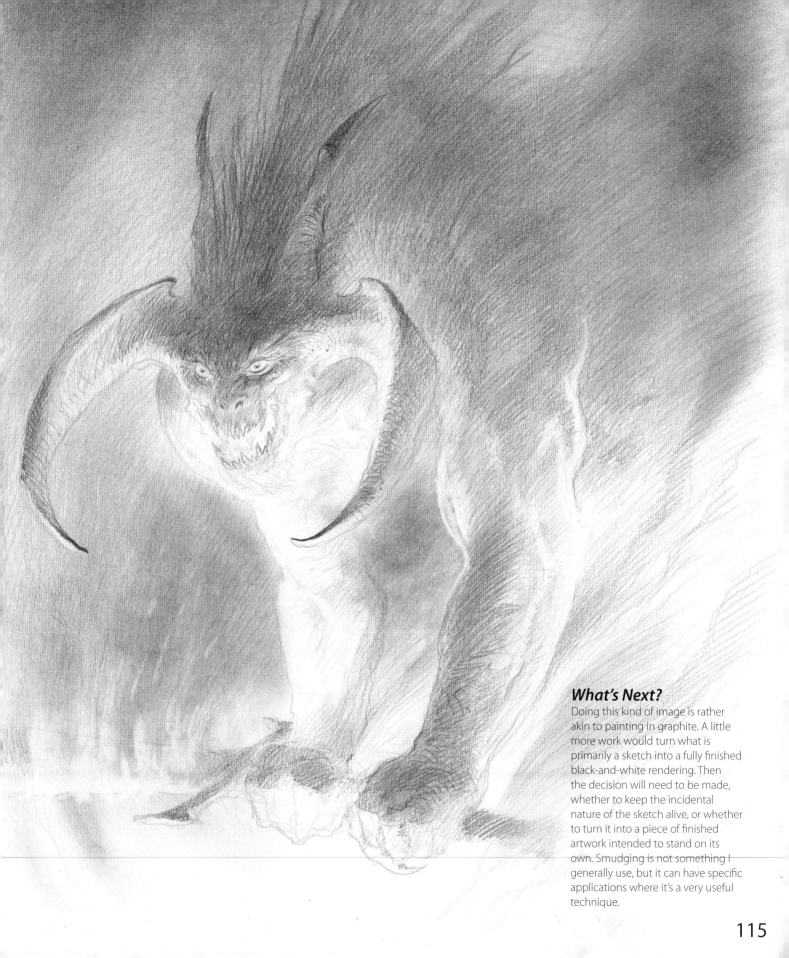

### What's Next?

Doing this kind of image is rather akin to painting in graphite. A little more work would turn what is primarily a sketch into a fully finished black-and-white rendering. Then the decision will need to be made, whether to keep the incidental nature of the sketch alive, or whether to turn it into a piece of finished artwork intended to stand on its own. Smudging is not something I generally use, but it can have specific applications where it's a very useful technique.

# MERMAID

Mermaids are so much a part of our common cultural heritage that not only do we have a solid idea of what they look like, but they lend themselves to being re-invented with ease. Half fish and half woman, the word mermaid comes from 'mere' – the Old English word for sea – and 'maid'.

## Project materials

- Derwent pastel pencils: terracotta, pale green, pale blue, grey blue, cadmium yellow, pale yellow, olive, white, pale flesh, dark flesh, pale violet, pale orange
- Grey-brown cartridge paper

## Ideas and inspiration

I wanted to draw a classical mermaid, as if she had suddenly appeared in front of an underwater diver, like a hallucination out of the sea's depths.

## Project techniques

- Basic human form and features
- Building coloured flesh tones
- Smudging with pastel pencils

## Project references

I dug out a number of pages cut out of photo and fashion magazines from my drawer marked 'Body – Female' to serve as reference. For the fish-tail, we won't see enough to require back up.

**1** With **terracotta**, sketch the head and flowing hair, the neck and the shoulder line. Work down into the arms and add the curve of the back, extending down into the tail. This is the basic outline of the mermaid.

**2** Work on the mermaid's head. Firmly establish the outline of the face and then sketch in the mouth, nostrils, eyes and eyebrows. Work out to create fin-edged ears, then start to add shape to the flowing hair.

**3** With the **pale green** pencil start lightly shading down the neck and right-hand shoulder. Switch to **pale flesh** to work down the shoulder and arm, and into the hips and tail.

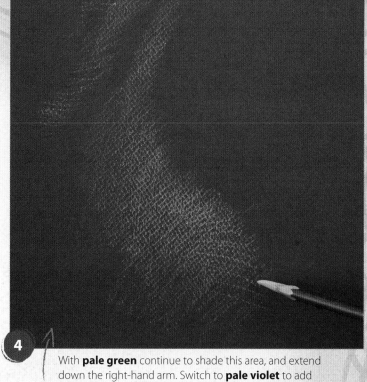

**4** With **pale green** continue to shade this area, and extend down the right-hand arm. Switch to **pale violet** to add further light shading to the arm, then cross-hatch down the shoulder and hips to build volume and texture.

**5** With **terracotta**, firmly establish the curve of the tail and sketch in the dorsal fin.

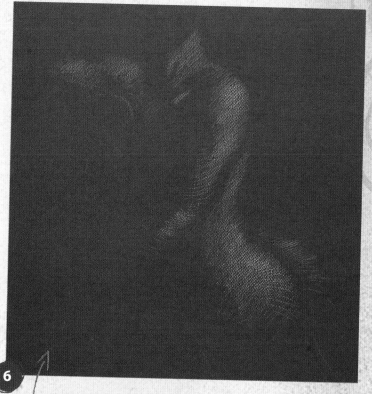

**6** Continue establishing the outline around the chest and into the arms as far as the hand, which is only suggested at this point (and a good thing too as it ends up getting erased and redrawn). Add shading to the neck and collarbone with **pale violet**, and work out into the left-hand arm. Shade down the right-hand arm, curving your strokes to enhance the arm contours. Using the **light green** lightly shade in the dorsal fin.

117

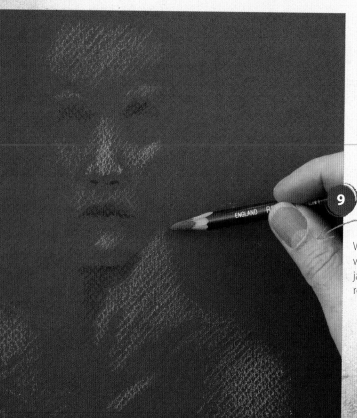

**7**

With **pale flesh**, start shading the mermaid's face over the forehead, eyebrows and nose, then down across the cheeks and onto the chin.

**8**

With **umber**, shade around the eye sockets, across the mouth and then down across the base of the chin and into the neck.

**9**

With the **pale green** lightly shade the nose, then with **terracotta** shade the bridge of the nose, the jaw line and the cheekbone, working down to re-define the neck as shown.

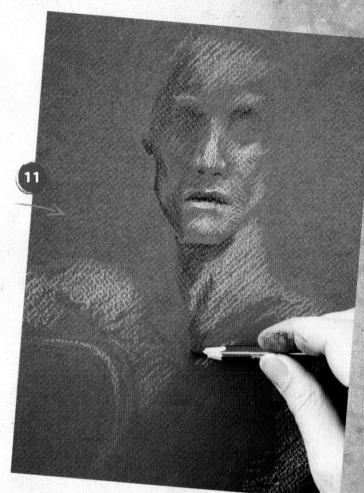

**10**

Continue to define the edge of the nose with terracotta, then use **pale flesh** to shade the lower lip.

With **dark green** shade above the upper lip and lightly up the lower half of the right-hand side of the face to define the facial contour. With **umber** darken the left-hand side of the face; apply a strong outline and then work light shading here. Lightly shade in the mouth. Shade into the chest area to create a v-shape around the collarbone and work light directional pencil strokes from the left-hand shoulder and across the chest.

**11**

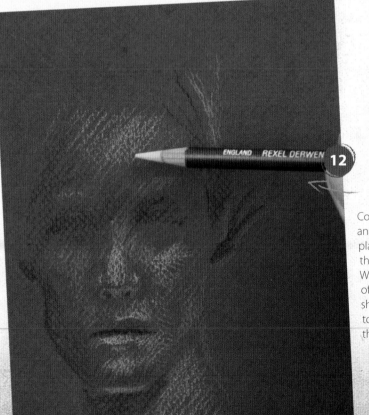

**12**

Continue with the umber and shade in the eye sockets and across the bridge of the nose. Use **dark flesh** to place a highlight on the chin, the lower lip and around the nostrils; then use **umber** to start defining the hair. With **cadmium yellow** establish the upward sweep of the hair and lightly shade across the forehead as shown. Continue down the nose and add a highlight to the right-hand cheek and the right-hand side of the upper lip.

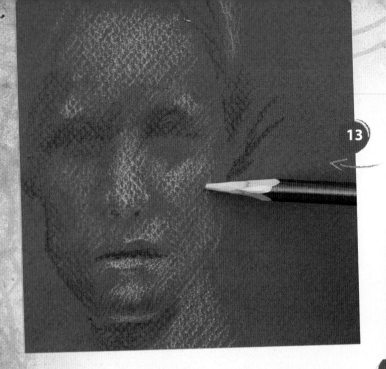

**13** With **pale violet** gently blend across the forehead and add highlights above each eyelid. Switch to **olive** and shade down the right-hand side of the face.

With **umber** deepen the shadow on the left-hand side of the face, establishing the hairline here. Continue to outline the other key facial details: the eye sockets, the nose, mouth and chin, and around the eyes. Also add some further shading to the chest.

**14**

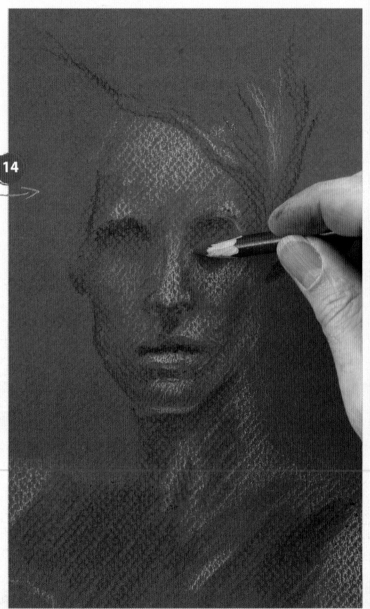

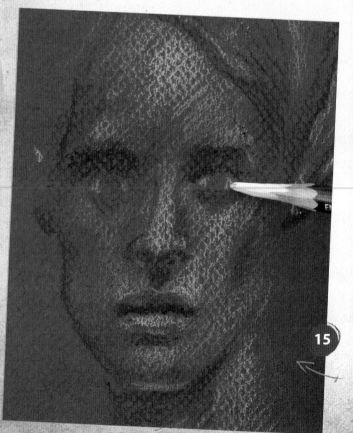

**15** With **pale flesh** continue highlighting the forehead, ear (working into the hair), upper lip and right-hand side of the face; then fill in the eyes.

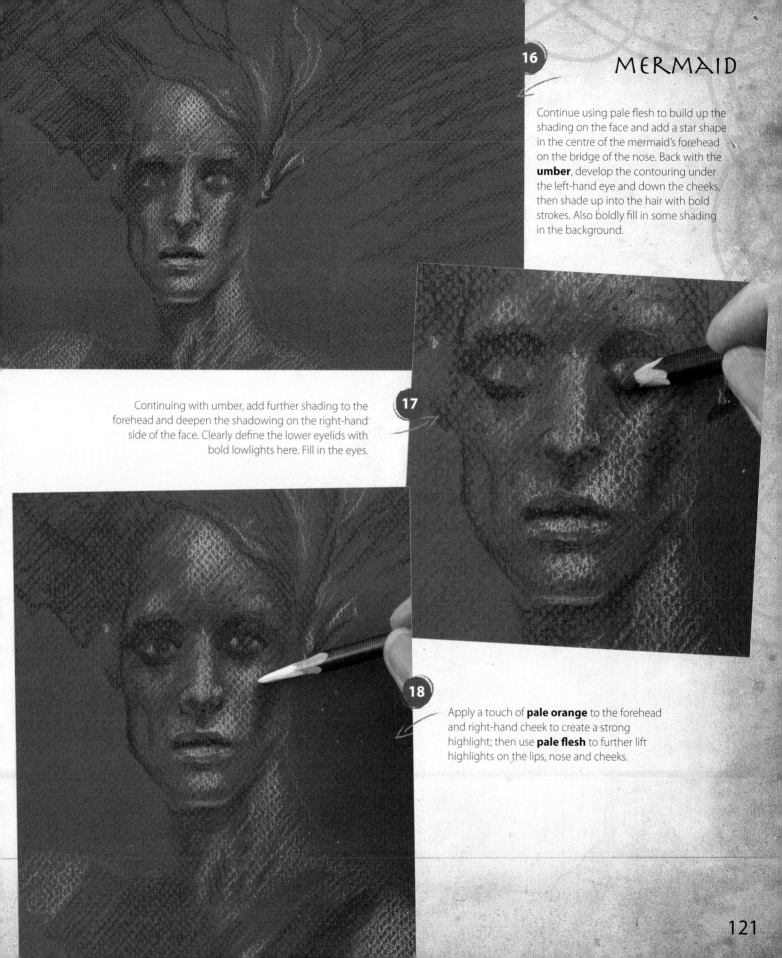

**16**

Continue using pale flesh to build up the shading on the face and add a star shape in the centre of the mermaid's forehead on the bridge of the nose. Back with the **umber**, develop the contouring under the left-hand eye and down the cheeks, then shade up into the hair with bold strokes. Also boldly fill in some shading in the background.

**17**

Continuing with umber, add further shading to the forehead and deepen the shadowing on the right-hand side of the face. Clearly define the lower eyelids with bold lowlights here. Fill in the eyes.

**18**

Apply a touch of **pale orange** to the forehead and right-hand cheek to create a strong highlight; then use **pale flesh** to further lift highlights on the lips, nose and cheeks.

# MERMAID

To darken the hair and background we are going to smudge. Use the craft knife to scrape **umber** shavings onto the background and hair.

**19**

Use facial tissues to smudge and blend the colour.

**20**

With **pale green** add some further shading to the cheek and forehead, and work strands up into the hair area. Then with **pale blue** boldly shade the background to the right of the neck.

Again, smudge.

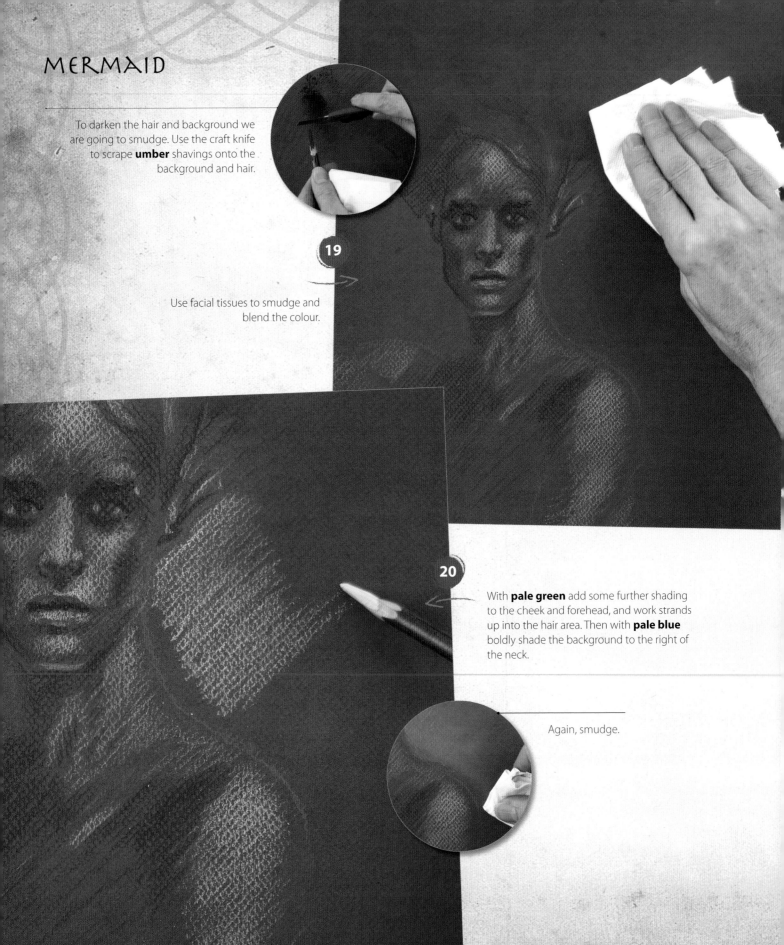

**21**

Continue shading the background on the left-hand side of the mermaid with the pale blue, gently smudging the colour as you go.

**22**

With **olive**, add further shading on the side of the neck, working down into the collarbone. Move back to the face to shade on the chin, cheeks and forehead. Then shade highlights onto the dorsal fin. Now with **white**, place highlights down the top of the arm, and then mark a small section of scales on the tail.

**23** With **umber**, add further depth around the eye sockets and lips. Then use **olive** to add highlights in the eyes.

**24** With **pale yellow**, add more strands into the hair and then smudge again. Switch to **olive** and apply light shading to follow the contours of the chest and then down around the right-hand arm; continue working down the arm with **pale blue** and add a fin by the wrist. With **terracotta,** sketch in a hand, and then use **pale violet** to lightly shade. With **olive,** cross-hatch over the hips and down the tail.

**25** With **pale yellow** and **olive** add further small highlights to the face and stranding in the hair. With **terracotta** further define the eyelids, the bridge of the nose, the chin and the outline of the torso deeply shading into the left-hand shoulder (see the final image). With **umber** finish the deeper facial shadows and contouring.

# INDEX

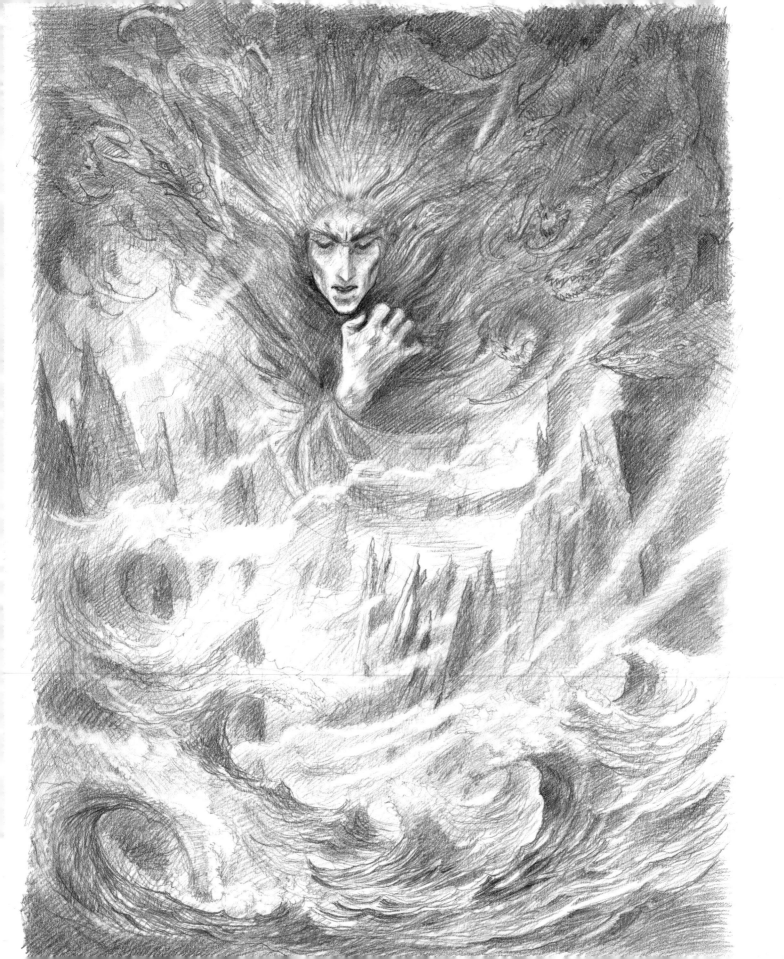

# ACKNOWLEDGMENTS

A decade ago, I wrote, with great conviction, "Why I Don't Do Sketches" as a chapter heading in my first art book. Since then, things have changed somewhat (proof it's never too late to learn something new, or, as one of my favorite sayings goes: "Errabundi saepe, semper certi").

This book would not have happened had not my editor Freya Dangerfield convincingly persuaded me that it could be done, nor without her patience and sterling on-the-fly note-taking skills. Thanks also to Kim Sayer, who managed to run tight, top-quality photo sessions while running a fever. Special thanks to Steve Unwin for the pick-up shoot.

Thanks to Alan Lee for the enthusiastic and wise words in the foreword, and for giving me the first sketchbook I have owned since high school, when we were working in New Zealand on *The Lord of the Rings* 10 years ago, the first of many, many sketchbooks filled with scribbles in graphite.

# ABOUT THE AUTHOR

John Howe was born in Vancouver in 1957 and grew up in British Columbia. He can't remember ever not drawing and John's talents and passion for the arts became evident at a young age; he then went on to study at the Ecole des Arts Décoratifs de Strasbourg. A gifted painter, illustrator and writer of children's books, John has been highly acclaimed for his work on J.R.R. Tolkien's books and associated merchandise over the last two decades. In recent years, John and fellow Tolkien illustrator Alan Lee have mesmerized audiences across the globe with their award-winning work as Conceptual Designers for Peter Jackson's *Lord of the Rings* film trilogy. John's work can frequently be seen in exhibitions throughout Europe, recently appearing at the prestigious Bibliothèque Nationale de Paris.

John's imaginative power is truly an inspiration. He is passionate about the need to construct fantasy on a foundation of authenticity, creating a world that is plausible and familiar in some way. His knowledge of the Medieval period is outstanding, and as a practitioner of living history, he extends his experience and knowledge of weapons, armour and fighting styles through re-enactments. This energy spills into his work – a distinct fusion of Medieval, Celtic, Gothic and Art Nouveau inspirations. And inextricably woven into John's fabric of detail, is his love of mythology and heroic tales. Combining serious craftsmanship and technical skill, vitality of communication and depth of dimensionality – John's art is as experimental as it is visual. John lives in Switzerland with wife Fataneh (also an illustrator) and son Dana.

*To view John's portfolio visit* www.john-howe.com

# WHEN IT'S ALL SAID AND DONE...

A drawing is never really done. It is simply a glimpse, at a given time, of an idea. Drawings are thoughts fixed in graphite lightly. They can be the best way to abandon an idea with no regrets, or a way to retain that fleeting something, to be revisiting months or even years later.

Now that we've reached the end of this book, I'd like to do it again. Better, possibly; different, certainly; because drawing is by nature a hasty exercise conducted in the court of circumstance where the muse has many suitors.

I would like to do simpler drawings, more complex drawings, the same drawings again, or a double handful of new ideas. I would like to do a book on drawing with no drawings at all. Drawings are never done, only the book that holds them.

Now that it's said and done, I've finally come to realize that it never really is, that pencils provide the perfect impermanence, the ultimate lightness of seeing, the line that is always between the lines in a sort of fractal meta-physicality – no matter how closely you depict and idea, there are always dozens more hidden within. That's what this book is hoping you will discover, that while practice makes good, perfect is always in the next sketch, that the only real line is the horizon.

It's no coincidence that etymology provides such solace; with each drawing you draw yourself closer to two things: understanding the nature of the world around you and depicting in patient graphite the worlds you have within. Like two mirrors placed face to face, the artist is somewhere in that infinity of reflection and counter-reflection. Hopefully armed with a pencil and a sketchpad.

A drawing is never really done.

John Howe, May 11, 2009

*Melkor's Theme*
*Cover art for "The Music of the Lord of the Rings Films" by Doug Adams. Reproduced with permission of the author.*

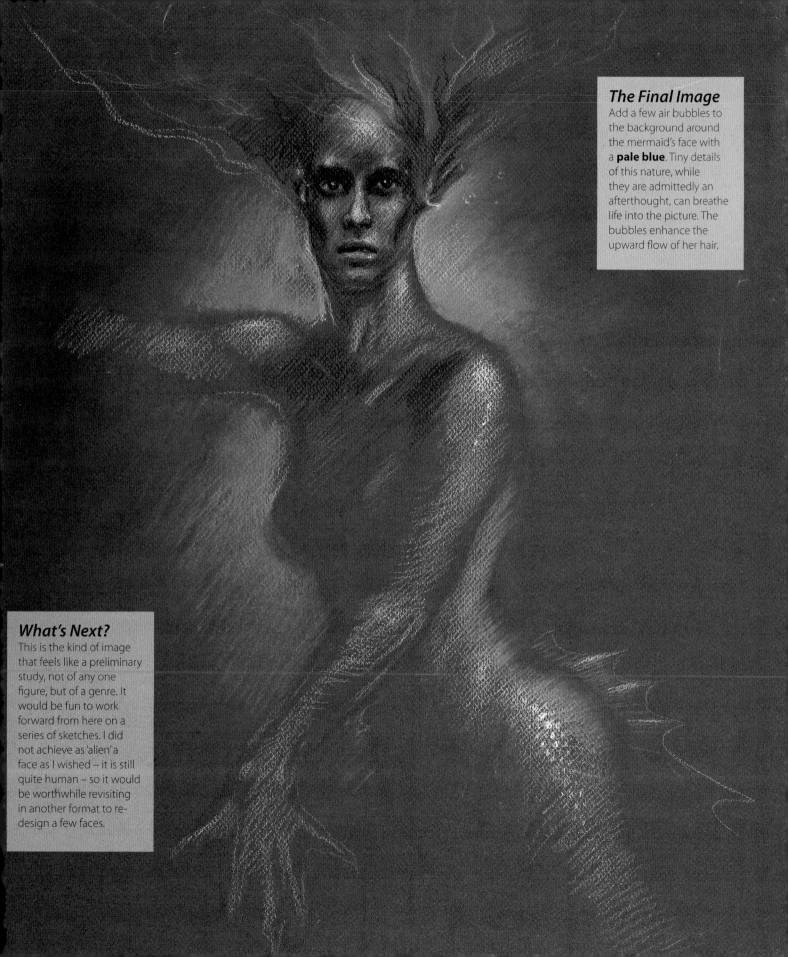

### The Final Image

Add a few air bubbles to the background around the mermaid's face with a **pale blue**. Tiny details of this nature, while they are admittedly an afterthought, can breathe life into the picture. The bubbles enhance the upward flow of her hair.

### What's Next?

This is the kind of image that feels like a preliminary study, not of any one figure, but of a genre. It would be fun to work forward from here on a series of sketches. I did not achieve as 'alien' a face as I wished – it is still quite human – so it would be worthwhile revisiting in another format to re-design a few faces.